DRAWING
CUTE ANIMALS
in Colored Pencil

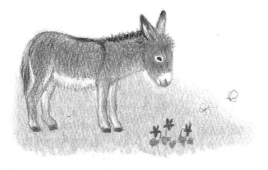

Quarry Books
100 Cummings Center, Suite 406L
Beverly, MA 01915

quarrybooks.com • craftside.typepad.com

QUARRY

Original Japanese title: Iroenpitsu De Kawaii Dobutsu
Originally published in Japanese by PIE International in 2011.

PIE International
2-32-4 Minami-Otsuka, Toshima-ku, Tokyo 170-0005 JAPAN
© 2011 Ai Akikusa / PIE International / PIE BOOKS

First published in the United States of America in 2014 by
Quarry Books, a member of
Quayside Publishing Group
100 Cummings Center
Suite 406-L
Beverly, Massachusetts 01915-6101
Telephone: (978) 282-9590
Fax: (978) 283-2742
www.quarrybooks.com
Visit www.Craftside.Typepad.com for a behind-the-scenes peek at our crafty world!

10 9 8 7 6 5 4 3 2 1

ISBN: 978-1-59253-936-9

INTRODUCTION

I wrote this book as if I am going on a trip to the zoo with YOU who says, "I love animals but I'm not good at drawing them." By watching animals closely we can learn about lots of things. Their eyes are placed on their heads so as to be able to scan their surroundings. They often have fluffy fur so as to keep themselves warm in the cold. Often, the shapes of their legs are made to be able to run at great speeds. They are all so different but each of their unique characteristics has a purpose.

In this book, I have included many suggestions of how to make your drawings look like the animal you are trying to depict. Since your drawing medium is colored pencils, they should be easy to draw. Don't try to draw a "perfectly illustrated" animal, but rather choose an animal you like and have lots of fun drawing it.

As you continue to draw animals, no doubt, you will soon want to go and meet some real animals. Then, on your next trip to the zoo, be sure to take your colored pencils and a sketch book. Your attempt at drawing them will for sure make you look at them more closely and your feeling of fondness will abound. So, turn to the next page of this book with a feeling of excitement, that is, just like how you feel when you pass through the gate of a zoo.

Let's start out by drawing small animals.

P.8

P.12

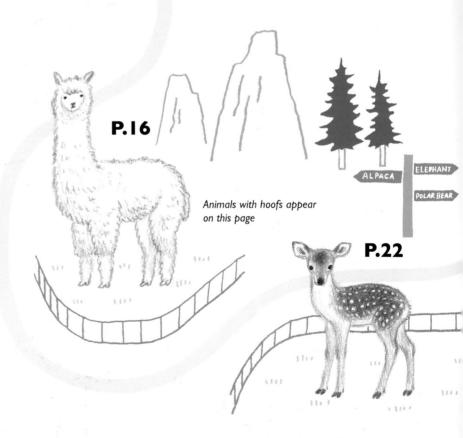

P.16

Animals with hoofs appear on this page

P.22

ALPACA ELEPHANT POLAR BEAR

P.26

P.36

Once illustrating becomes fun why not try challenging some large animals.

P.42

P.50

P.56

P.60

How many horns does a giraffe have?

LION

ELEPHANT

GIRAFFE

P.68

P.74

P.96

P.82

P.90

P.84

RABBIT

Rabbits are made of lots of curved lines. So, draw your lines as if you are stroking one. Draw your lines imagining the fluffy feeling of when you cuddle a rabbit and color in the body as if you are blowing air into it.

EUROPEAN RABBIT

Species order and family: *Lagomorpha, Leporidae*

Body length: 1.1–1.6 ft (35–50 cm)
(tail length 2–3 in [4.5–7.5 cm])

Weight: 3.3–6.6 lbs (1.5–3 kg)

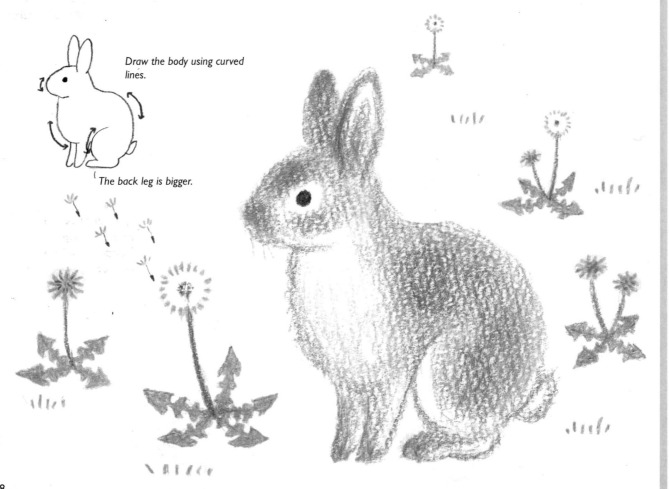

Draw the body using curved lines.

The back leg is bigger.

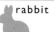

1.

Draw the outline of the body using brown. Draw the ears imagining it to be a long leaf.

2.

Next, draw the other ear. Draw its forehead and right on down to its nose.

*Don't draw the forehead to the nose in one stroke but rather in two different strokes.

forehead

nose

3.

Draw its chest and its back down to its buttocks using soft curved lines.

back to its buttocks

chest

4.

If you draw its two front feet lined up together it will look real cute.

9

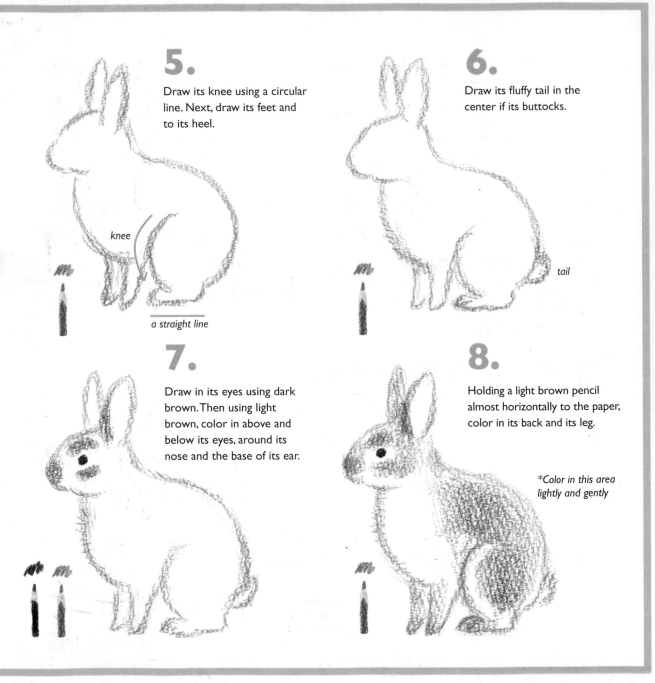

5.

Draw its knee using a circular line. Next, draw its feet and to its heel.

knee

a straight line

6.

Draw its fluffy tail in the center if its buttocks.

tail

7.

Draw in its eyes using dark brown. Then using light brown, color in above and below its eyes, around its nose and the base of its ear.

8.

Holding a light brown pencil almost horizontally to the paper, color in its back and its leg.

Color in this area lightly and gently

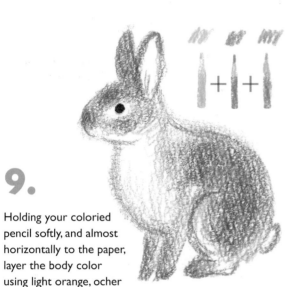

9.

Holding your coloried pencil softly, and almost horizontally to the paper, layer the body color using light orange, ocher (a rustlike color) and gray.

10.

Color the front and back feet gray and add a touch of pink to the area inside the ear.

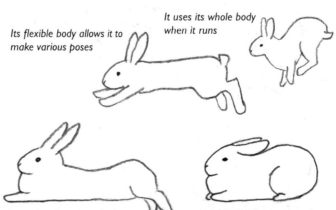

VARIOUS RABBIT POSES

Let's try drawing the soft body lines of a rabbit

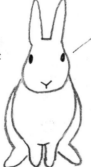

From the front its face looks frostbit

Two big eyes on both sides of its face

Sitting still, its body looks very compact

Its flexible body allows it to make various poses

It uses its whole body when it runs

In a relaxed mode its body becomes flat

Laying its ears down, its body becomes circular

11

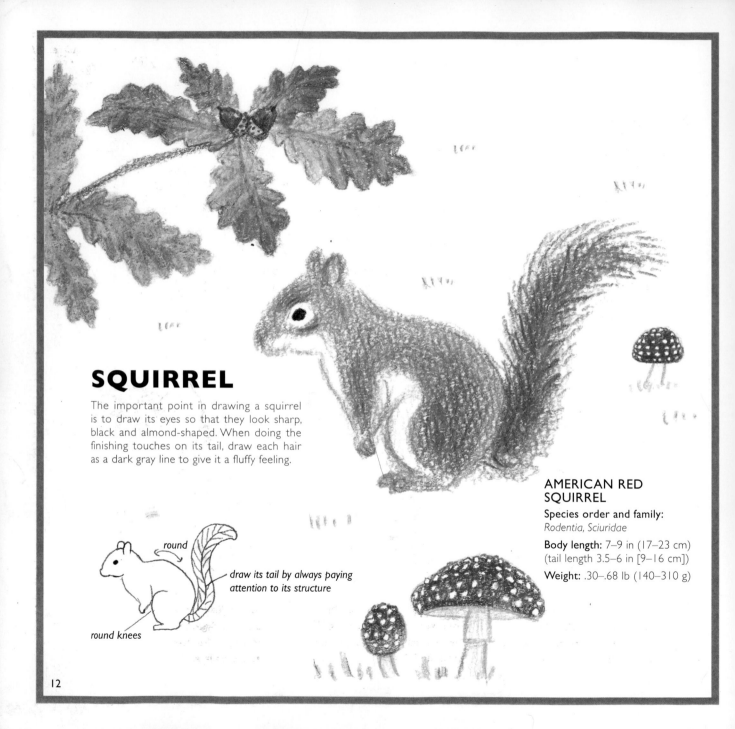

SQUIRREL

The important point in drawing a squirrel is to draw its eyes so that they look sharp, black and almond-shaped. When doing the finishing touches on its tail, draw each hair as a dark gray line to give it a fluffy feeling.

round

draw its tail by always paying attention to its structure

round knees

AMERICAN RED SQUIRREL

Species order and family:
Rodentia, Sciuridae

Body length: 7–9 in (17–23 cm)
(tail length 3.5–6 in [9–16 cm])

Weight: .30–.68 lb (140–310 g)

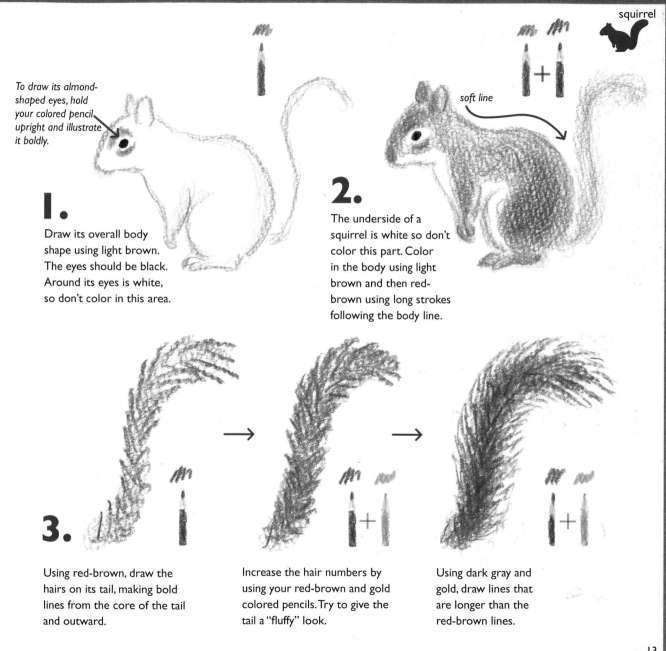

To draw its almond-shaped eyes, hold your colored pencil upright and illustrate it boldly.

1.

Draw its overall body shape using light brown. The eyes should be black. Around its eyes is white, so don't color in this area.

2.

soft line

The underside of a squirrel is white so don't color this part. Color in the body using light brown and then red-brown using long strokes following the body line.

3.

Using red-brown, draw the hairs on its tail, making bold lines from the core of the tail and outward.

Increase the hair numbers by using your red-brown and gold colored pencils. Try to give the tail a "fluffy" look.

Using dark gray and gold, draw lines that are longer than the red-brown lines.

13

SMALL ANIMALS

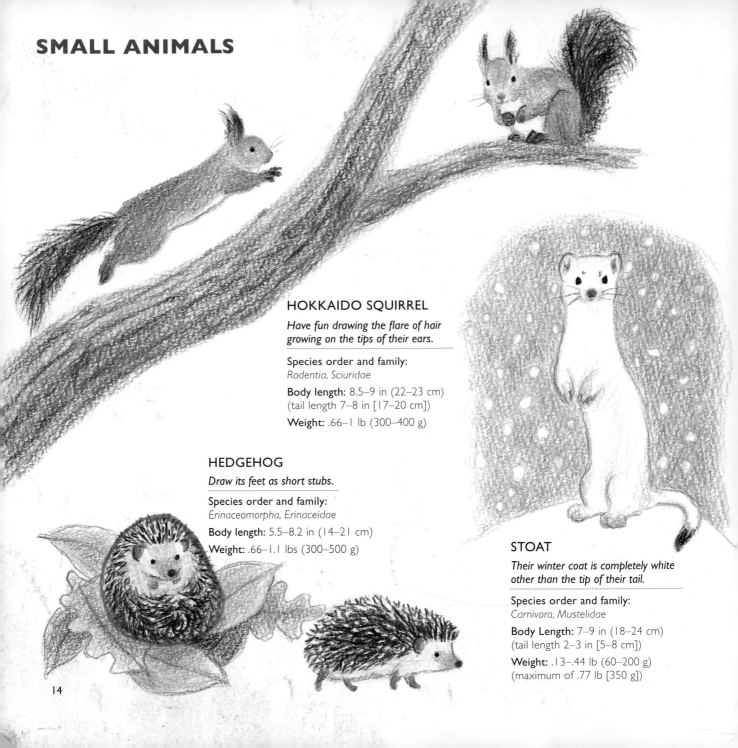

HOKKAIDO SQUIRREL

Have fun drawing the flare of hair growing on the tips of their ears.

Species order and family:
Rodentia, Sciuridae

Body length: 8.5–9 in (22–23 cm)
(tail length 7–8 in [17–20 cm])

Weight: .66–1 lb (300–400 g)

HEDGEHOG

Draw its feet as short stubs.

Species order and family:
Erinaceomorpha, Erinaceidae

Body length: 5.5–8.2 in (14–21 cm)

Weight: .66–1.1 lbs (300–500 g)

STOAT

Their winter coat is completely white other than the tip of their tail.

Species order and family:
Carnivora, Mustelidae

Body Length: 7–9 in (18–24 cm)
(tail length 2–3 in [5–8 cm])

Weight: .13–.44 lb (60–200 g)
(maximum of .77 lb [350 g])

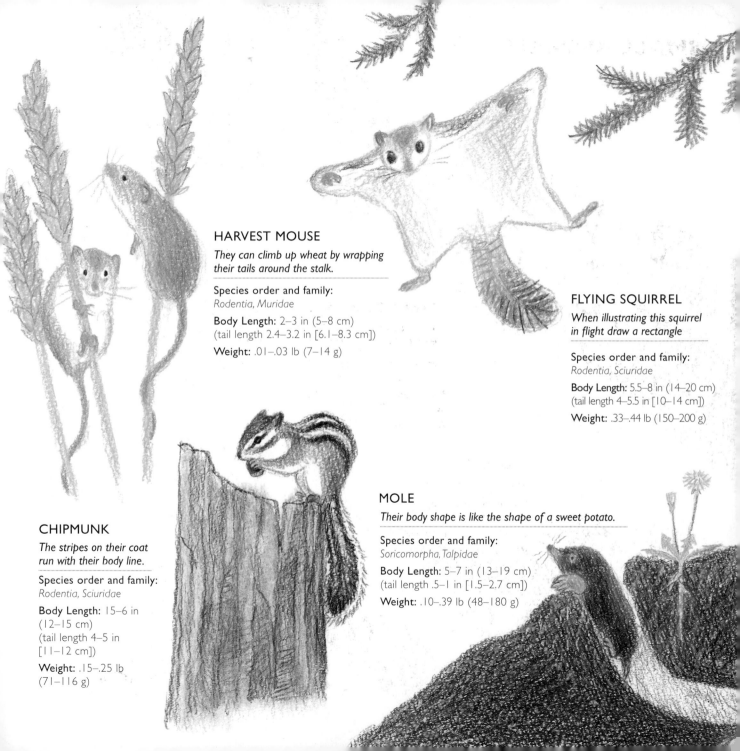

HARVEST MOUSE

They can climb up wheat by wrapping their tails around the stalk.

Species order and family:
Rodentia, Muridae

Body Length: 2–3 in (5–8 cm)
(tail length 2.4–3.2 in [6.1–8.3 cm])

Weight: .01–.03 lb (7–14 g)

FLYING SQUIRREL

When illustrating this squirrel in flight draw a rectangle

Species order and family:
Rodentia, Sciuridae

Body Length: 5.5–8 in (14–20 cm)
(tail length 4–5.5 in [10–14 cm])

Weight: .33–.44 lb (150–200 g)

CHIPMUNK

The stripes on their coat run with their body line.

Species order and family:
Rodentia, Sciuridae

Body Length: 15–6 in
(12–15 cm)
(tail length 4–5 in
[11–12 cm])

Weight: .15–.25 lb
(71–116 g)

MOLE

Their body shape is like the shape of a sweet potato.

Species order and family:
Soricomorpha, Talpidae

Body Length: 5–7 in (13–19 cm)
(tail length .5–1 in [1.5–2.7 cm])

Weight: .10–.39 lb (48–180 g)

ALPACA

ALPACA
Species order and family: *Vicugna pacos*
Body length: 4–7 ft (1200–2250 mm)
Weight: 121–143 lbs (55–65 kg)

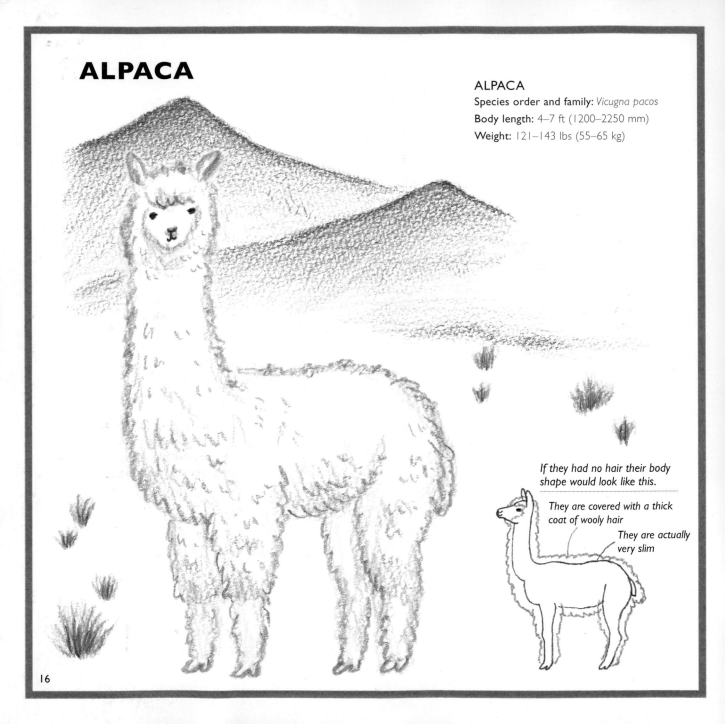

If they had no hair their body shape would look like this.

They are covered with a thick coat of wooly hair

They are actually very slim

1.

Draw the outline of the head using ocher. Stand the ears straight up.

2.

Draw a long line from its neck to its chest.

3.

Draw its legs as if it were wearing knickers.

4.

Draw its stomach so that it has a little bulge. Next, draw its back legs and its tail.

5.

Draw its face like a triangular rice ball sitting on its side. All these lines should be illustrated using your ocher.

17

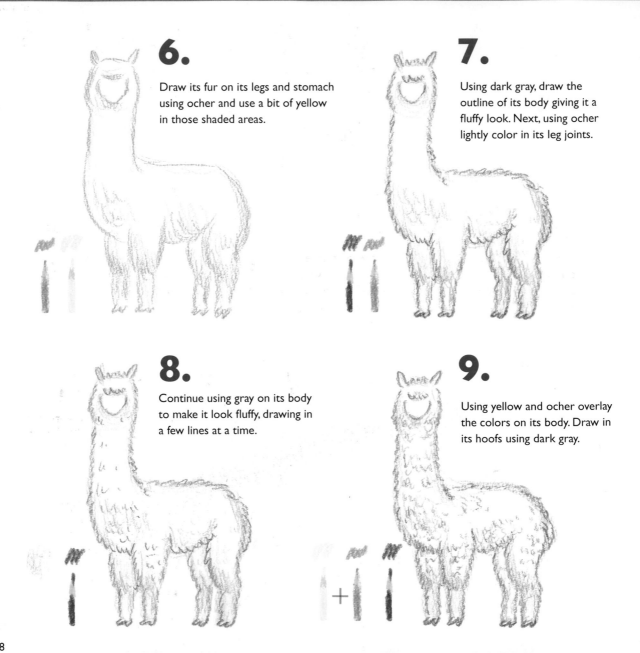

6.

Draw its fur on its legs and stomach using ocher and use a bit of yellow in those shaded areas.

7.

Using dark gray, draw the outline of its body giving it a fluffy look. Next, using ocher lightly color in its leg joints.

8.

Continue using gray on its body to make it look fluffy, drawing in a few lines at a time.

9.

Using yellow and ocher overlay the colors on its body. Draw in its hoofs using dark gray.

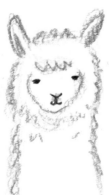

alpaca

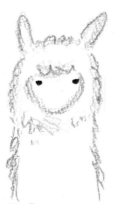

10.

Draw in its eyes using black. Its eyes are on both sides of its face so position the eyes at the edges.

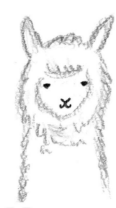

11.

Draw in its nose and mouth, again using black. You can illustrate its nose by making the letter "Y."

12.

Color in the insides of its ears and around its nose using pink.

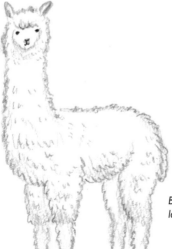

Brown alpacas also look real cute.

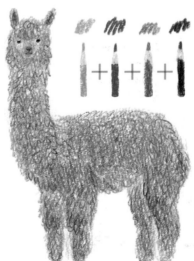

Try making a gradation of brown.

Gold, red-brown, light brown, dark brown etc.

By overlaying colors you can make a brown alpaca.

19

ALPACA FARM

Mother and child

An alpaca eating grass

A dark brown alpaca

Sprawled out on the ground, sleeping

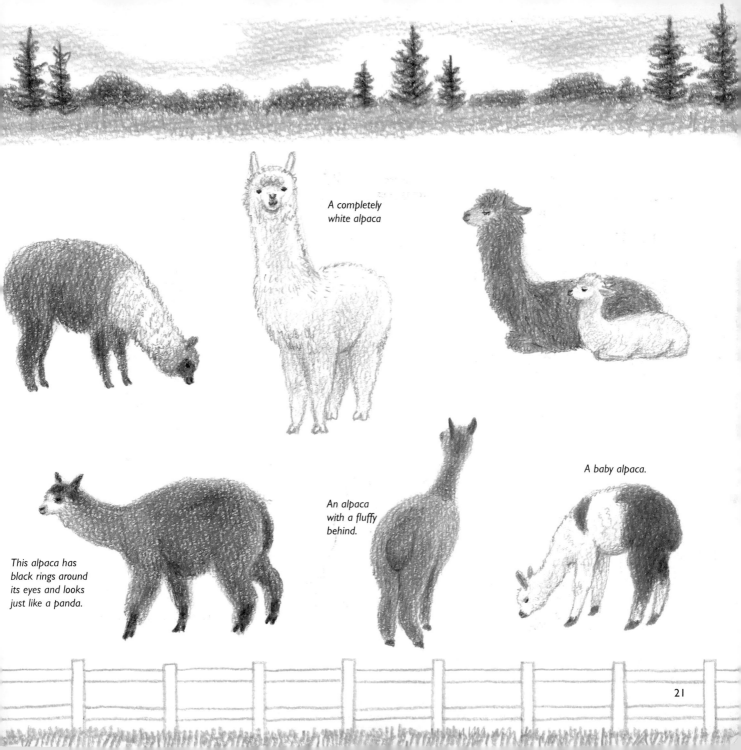

A completely
white alpaca

This alpaca has
black rings around
its eyes and looks
just like a panda.

An alpaca
with a fluffy
behind.

A baby alpaca.

21

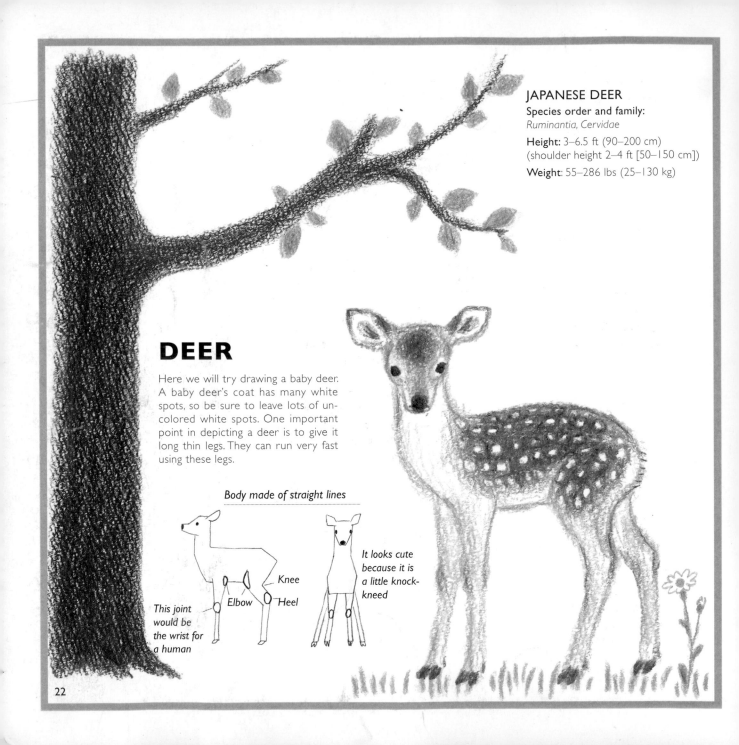

JAPANESE DEER
Species order and family:
Ruminantia, Cervidae
Height: 3–6.5 ft (90–200 cm)
(shoulder height 2–4 ft [50–150 cm])
Weight: 55–286 lbs (25–130 kg)

DEER

Here we will try drawing a baby deer. A baby deer's coat has many white spots, so be sure to leave lots of un-colored white spots. One important point in depicting a deer is to give it long thin legs. They can run very fast using these legs.

Body made of straight lines

This joint would be the wrist for a human

Elbow

Knee

Heel

It looks cute because it is a little knock-kneed

22

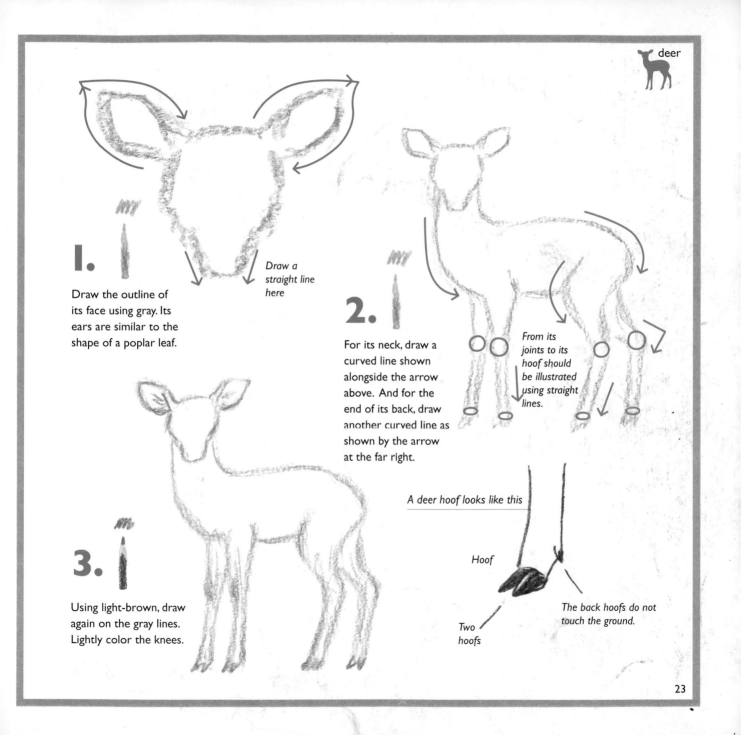

1.

Draw the outline of its face using gray. Its ears are similar to the shape of a poplar leaf.

Draw a straight line here

2.

For its neck, draw a curved line shown alongside the arrow above. And for the end of its back, draw another curved line as shown by the arrow at the far right.

From its joints to its hoof should be illustrated using straight lines.

3.

Using light-brown, draw again on the gray lines. Lightly color the knees.

A deer hoof looks like this

Hoof

Two hoofs

The back hoofs do not touch the ground.

23

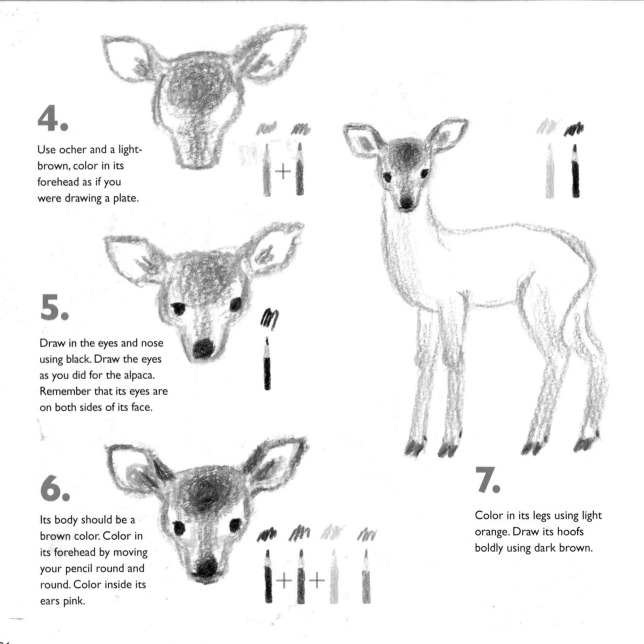

4.

Use ocher and a light-brown, color in its forehead as if you were drawing a plate.

5.

Draw in the eyes and nose using black. Draw the eyes as you did for the alpaca. Remember that its eyes are on both sides of its face.

6.

Its body should be a brown color. Color in its forehead by moving your pencil round and round. Color inside its ears pink.

7.

Color in its legs using light orange. Draw its hoofs boldly using dark brown.

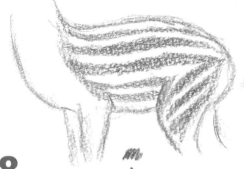

8.

Use light brown to draw stripes along its body.

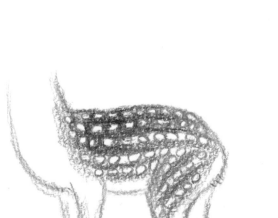

9.

Use light brown to draw circles inside the white stripes. Next, use red-brown and dark-brown to color in between the circles.

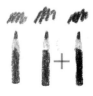

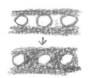

10.

Holding your dark brown pencil vertically, draw the rough hairs on its buttocks. Using the same dark brown, draw over its joints and its heel.

25

PIG

A pig's body line is actually made up of many straight lines. Imagine that you are drawing a drum can then it will be easy to illustrate a pig. Color in its body pink, and soon your pig will be finished.

Imagine you are drawing a barrel

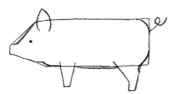

Draw a barrel and then
round out the edges.

PIG (YORKSHIRE)
Species order and family:
Artiodactyla, Suidae

Height: 3 ft (1 m)

Weight: 176–440 lbs
(80–200 kg)

1.

Using light orange, draw the outline of the body. Stand its ears up and draw its nose as if you were drawing a tube.

2.

Draw its front feet. Its back should be a bit rounded.

3.

Draw its leg with a rounded knee and a sharp heel. Draw its stomach as a straight line.

Draw its tail in one stroke.

4.

Next, draw its curly tail.

5.

Highlight the light orange body line with gray. Also use gray to color inside its ear.

6.

Using gray, also highlight the tail and the hoofs.

Number and shape of hooves

There are four hooves on each leg of a pig, two in the front and two in the back. The two in the back are located higher up, so they are like heels on high-heeled shoes.

Two hooves

Two hooves

High-heeled shape

7.

Holding your orange coloring pencil horizontally to the paper, gently color in the body of the pig.

8.

Gently color the face pink, as if you were putting makeup on its face.

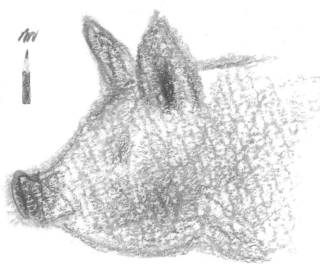

Holding your pencil horizontally to the paper, color in the body using the whole surface of your pencil lead.

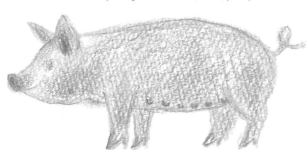

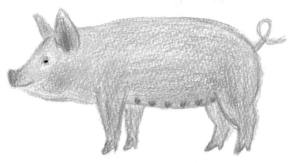

9.

Color the whole body orange and then pink. Next, color its teats pink.

10.

Draw in its eyes using black. Add light brown and purple in places to give your illustration depth.

29

ANIMALS WITH HOOVES

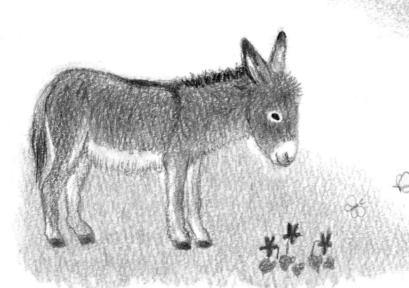

SHEEP

Sheep with black faces are called Suffolk. Sheep with white faces are called Charollais.

Species order and family:
Artiodactyla, Bovidae
There are over 300 different breeds.

Height: male: 1–2 ft (45–85 cm) female: 1–2 ft (40–80 cm)

Weight: male 55–330 lbs (25–150 kg) female 44–230 lbs (20–105 kg)

COW

Jersey is a breed with big eyes and brown bodies.

Species order and family:
Artiodactyla, Bovidae.
There are over 200 breeds of cows.

Height: Up to 6 ft (180 cm)

Weight: 990–4,000 lbs (450–1,800 kg)

DONKEY

They have big ears and the hair on their underside is white so that part should not be colored in.

Species order and family: *Perissodactyla, Equidae*

Height: 6.5–7 ft (2–2.5 m) (hair length is 12–20 in [30–50 cm])

Weight: 440–660 lbs (200–300 kg)

REINDEER

They have wide hooves so as to be able to walk easily on snow.

Species order and family: *Cetartiodactyla, Cervidae*

Height: 4–7 ft (1.2–2.2 m)

Weight: 130–550 lbs (60–250 kg)

TWO-HUMPED CAMEL

Their unique features are the two humps on their backs and their long waterfowl-like necks.

Species order and family: *Artiodactyla, Camelidae*

Height: 7–11 ft (2.2–3.5 m)

Weight: 660–1,430 lbs (300–650 kg)

WHOSE FOOTPRINTS ARE THESE?

1

2

3

4

5

6

7

8

33

PARENT AND CHILD

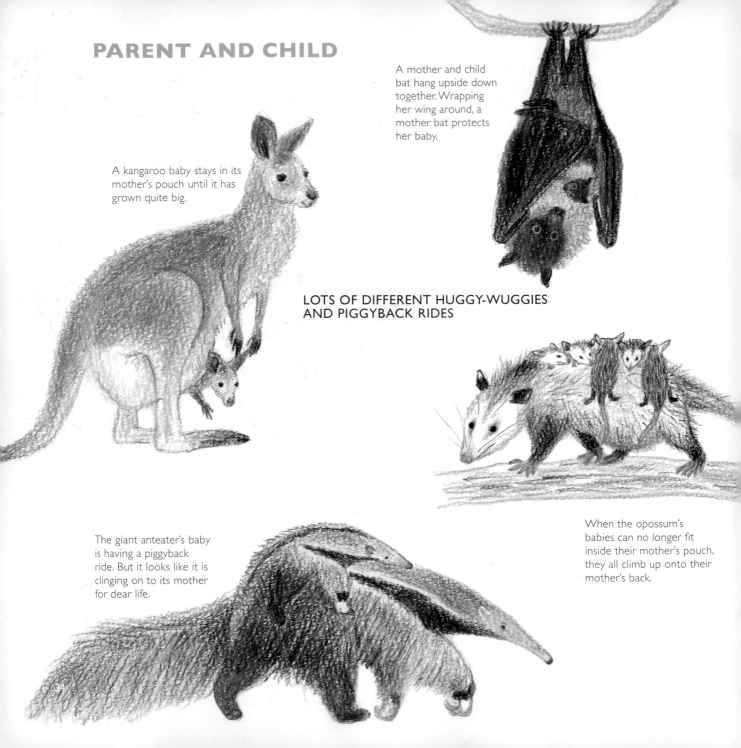

A mother and child bat hang upside down together. Wrapping her wing around, a mother bat protects her baby.

A kangaroo baby stays in its mother's pouch until it has grown quite big.

LOTS OF DIFFERENT HUGGY-WUGGIES AND PIGGYBACK RIDES

When the opossum's babies can no longer fit inside their mother's pouch, they all climb up onto their mother's back.

The giant anteater's baby is having a piggyback ride. But it looks like it is clinging on to its mother for dear life.

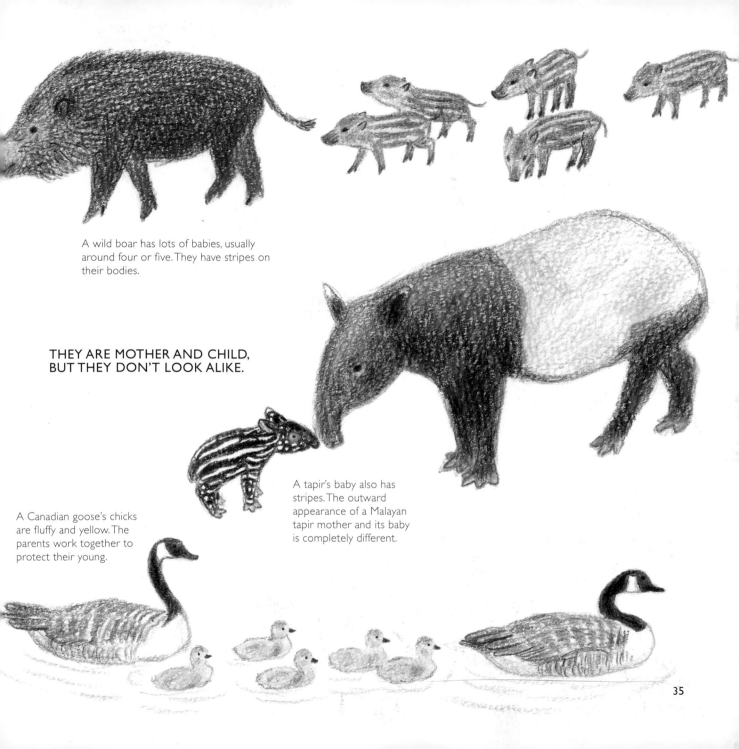

A wild boar has lots of babies, usually around four or five. They have stripes on their bodies.

THEY ARE MOTHER AND CHILD, BUT THEY DON'T LOOK ALIKE.

A tapir's baby also has stripes. The outward appearance of a Malayan tapir mother and its baby is completely different.

A Canadian goose's chicks are fluffy and yellow. The parents work together to protect their young.

ELEPHANT

Various shades of gray should be used to illustrate the leathery and wrinkled hide of an elephant. Don't forget to draw in the hairs on its head and back.

The overall shape of an elephant

A hump on top of its head

Hairs grow on this area

From about here the back line begins to drop

Front-leg pit

← Elbow

Many wrinkles can be found on parts that are moved often

Its bottom lip

Knee

Front foot

Its nose is like an oversized top lip

There are five hooves on its front foot and four on its back foot

ASIAN ELEPHANT
Species order and family:
Proboscidea, Elephantidae

Height: 16–20 ft (5–6 m)
(6.5–10 ft [2–3 m] to
its shoulder)

Weight: male: up to 5.4 tons,
female: 2–3 tons

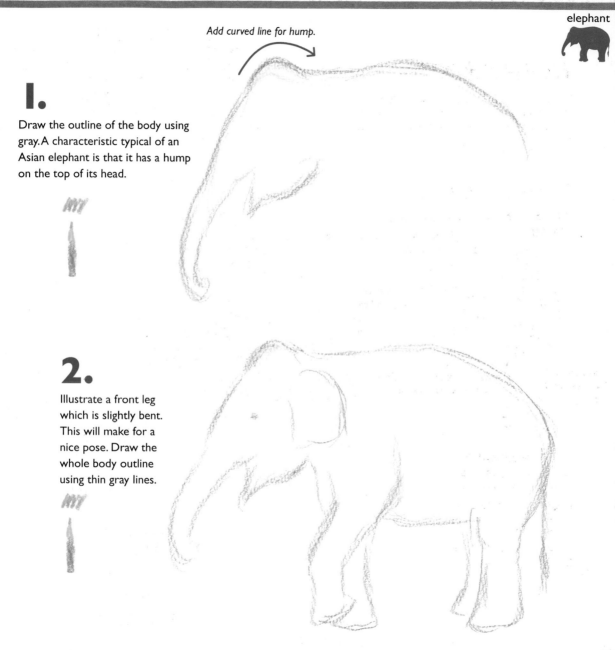

Add curved line for hump.

1.

Draw the outline of the body using gray. A characteristic typical of an Asian elephant is that it has a hump on the top of its head.

2.

Illustrate a front leg which is slightly bent. This will make for a nice pose. Draw the whole body outline using thin gray lines.

3.

Draw its nails using dark gray. Stand your pencil upright and color in the whole body to give it a leathery look.

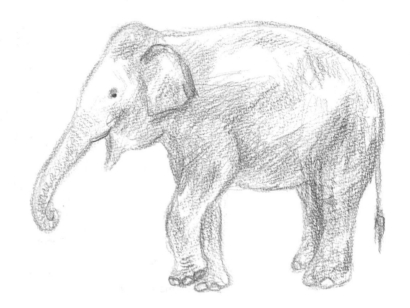

4.

Using gray and light orange, color in the whole body. Stand you pencil upright as you color to give the hide a rough-looking feel.

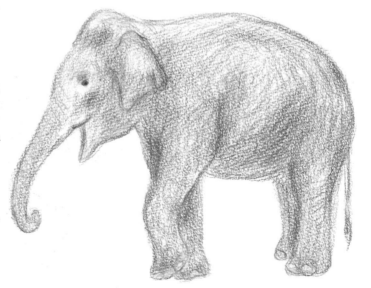

5.

Using gray and dark brown, highlight the hump on its head, its ears, and the wrinkles on its legs.

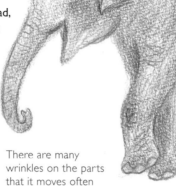

There are many wrinkles on the parts that it moves often

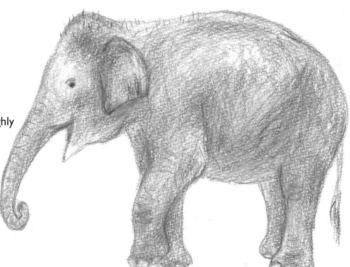

6.

Using dark brown, draw in the hairs growing on its head and shoulder area. Using white, roughly color in the parts of its body where its hide is smooth.

39

A LITTLE MORE
ABOUT ELEPHANTS

From the front we can see
two humps on its head.

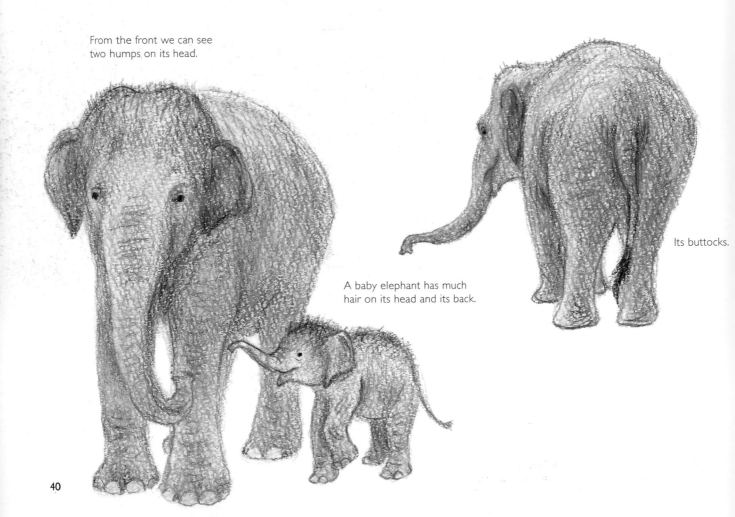

Its buttocks.

A baby elephant has much
hair on its head and its back.

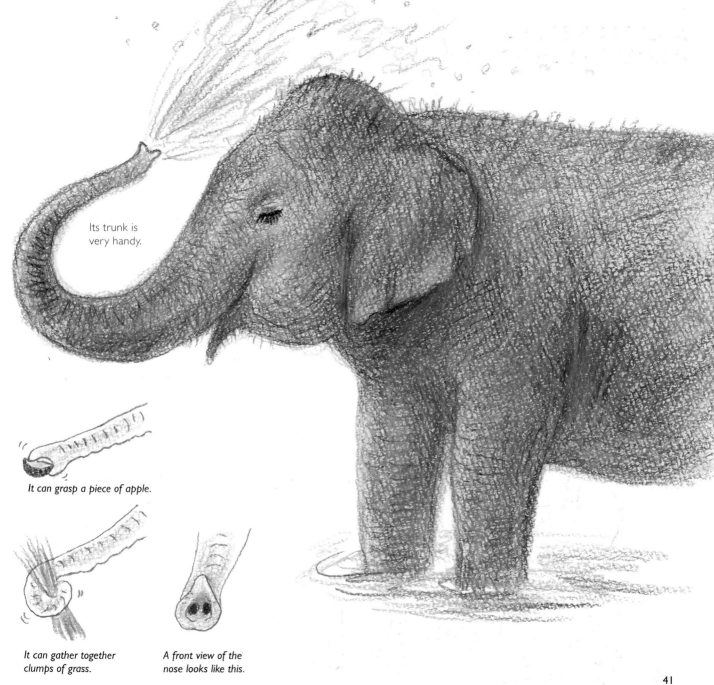

Its trunk is
very handy.

It can grasp a piece of apple.

It can gather together
clumps of grass.

A front view of the
nose looks like this.

41

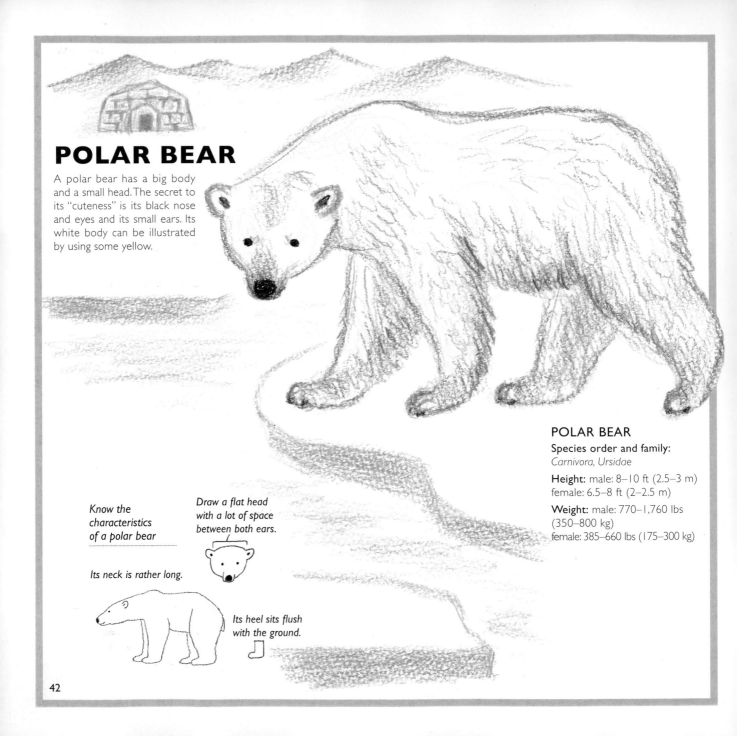

POLAR BEAR

A polar bear has a big body and a small head. The secret to its "cuteness" is its black nose and eyes and its small ears. Its white body can be illustrated by using some yellow.

POLAR BEAR

Species order and family:
Carnivora, Ursidae

Height: male: 8–10 ft (2.5–3 m)
female: 6.5–8 ft (2–2.5 m)

Weight: male: 770–1,760 lbs (350–800 kg)
female: 385–660 lbs (175–300 kg)

Know the characteristics of a polar bear

Draw a flat head with a lot of space between both ears.

Its neck is rather long.

Its heel sits flush with the ground.

This line is rather long.

round *round*

1.

Draw its face using gray. Illustrate in the following order: ears, cheeks, nose.

2.

Draw the line from its neck to the top of its shoulder. Next, draw the line from its shoulder to its waist.

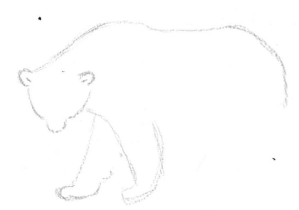

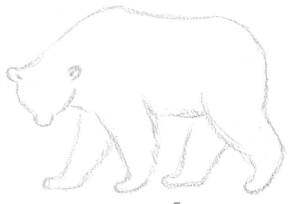

3.

Draw its front legs after illustrating its neck.

4.

Draw its back legs. Make it look as if it is wearing boots.

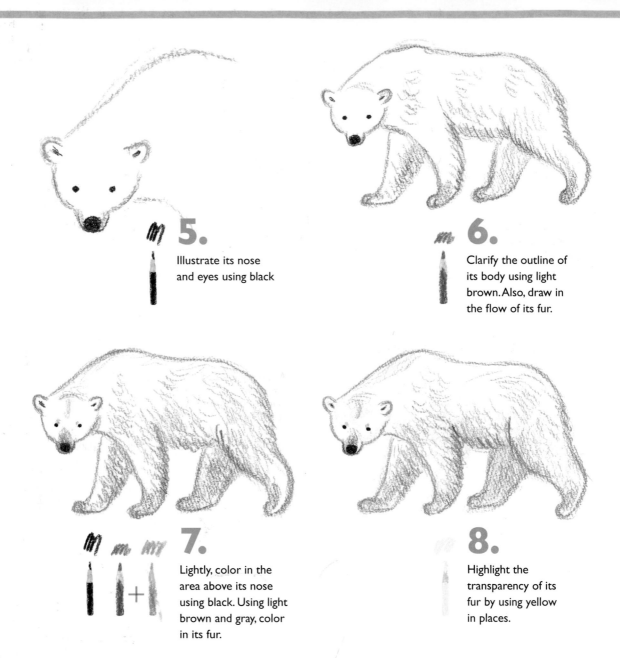

5.
Illustrate its nose and eyes using black

6.
Clarify the outline of its body using light brown. Also, draw in the flow of its fur.

7.
Lightly, color in the area above its nose using black. Using light brown and gray, color in its fur.

8.
Highlight the transparency of its fur by using yellow in places.

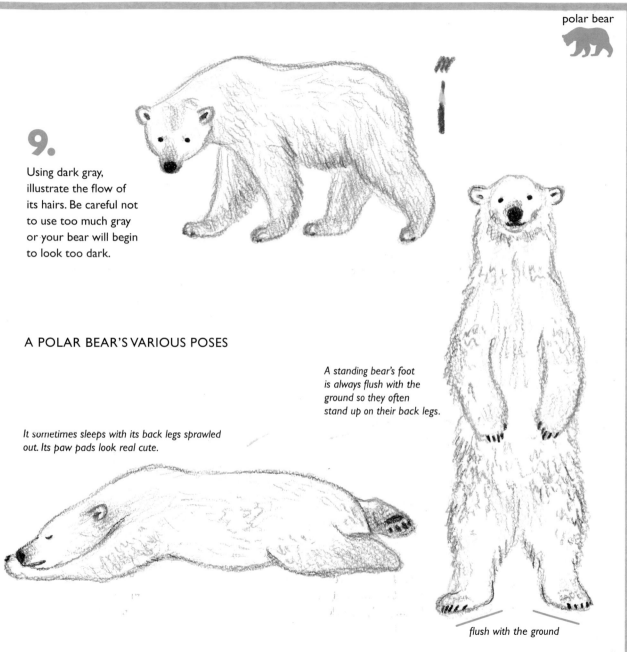

9.

Using dark gray, illustrate the flow of its hairs. Be careful not to use too much gray or your bear will begin to look too dark.

A POLAR BEAR'S VARIOUS POSES

A standing bear's foot is always flush with the ground so they often stand up on their back legs.

It sometimes sleeps with its back legs sprawled out. Its paw pads look real cute.

flush with the ground

45

ALL KINDS OF BEARS

ASIAN BLACK BEAR

They have a white moon shape on their chest.

Species order and family: *Ursus, Thibetanus*
Body Length: 3.5–5 ft (1.1–1.5 m)
Weight: 88–330 lbs (40–150 kg)

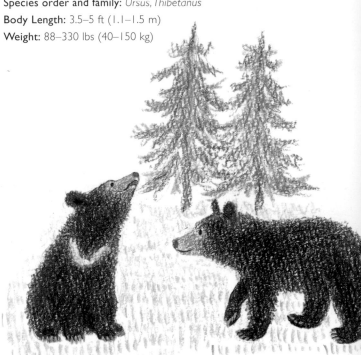

MALAYAN SUN BEAR

It has very short hair so its hide is sleek and it looks like it is wearing pantyhose.

Species order and family:
Ursus, Malayanus
Body Length: 3–5 ft (1–1.5 m)
Weight: 55–140 lbs (25–65 kg)

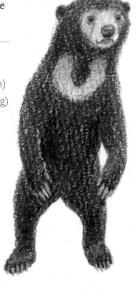

BROWN BEAR

They have thick fur. Include in your illust their favorite food in the fall, salmon.

Species order and family: *Carnivora, U*
Body Length: 4–6 ft (1.3–2 m)
Weight: male: 265–770 lbs (120–350 female: 110–440 lbs (50–200 kg)

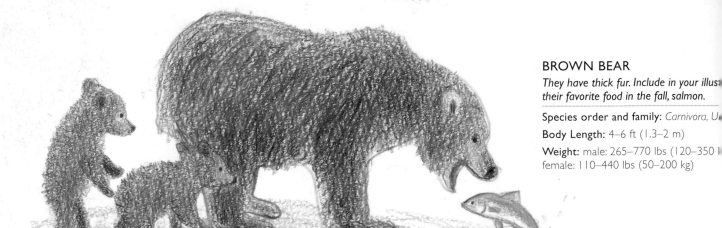

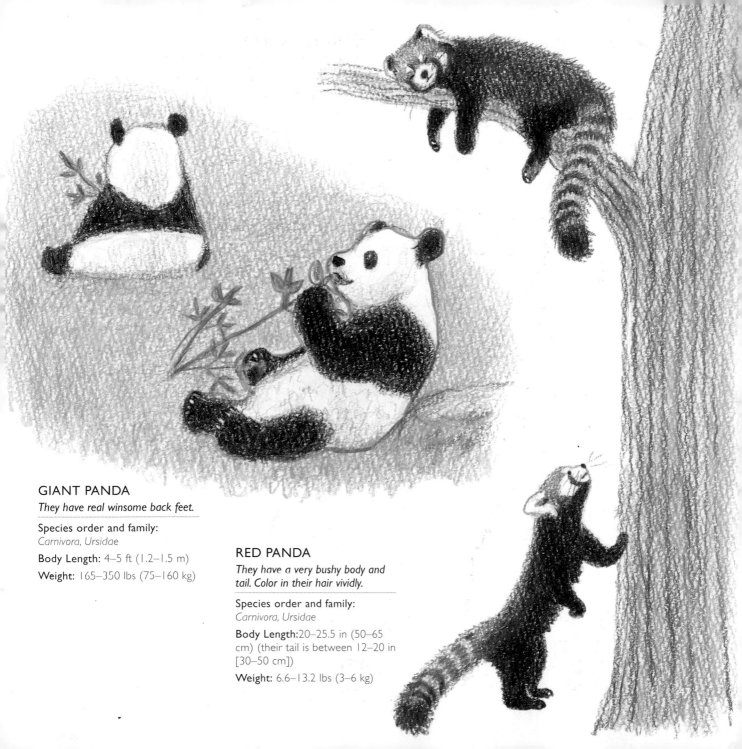

GIANT PANDA
They have real winsome back feet.

Species order and family:
Carnivora, Ursidae

Body Length: 4–5 ft (1.2–1.5 m)

Weight: 165–350 lbs (75–160 kg)

RED PANDA
They have a very bushy body and tail. Color in their hair vividly.

Species order and family:
Carnivora, Ursidae

Body Length: 20–25.5 in (50–65 cm) (their tail is between 12–20 in [30–50 cm])

Weight: 6.6–13.2 lbs (3–6 kg)

GOOD NIGHT

CURLING UP TO SLEEP

Dormouse lower their body temperature and curl up into a ball shape to hibernate during the winter.

A fox's tail is both its pillow and its scarf.

A mother and child koala curl up together like a ball to sleep.

A kangaroo's tail is both its pillow and its cushion.

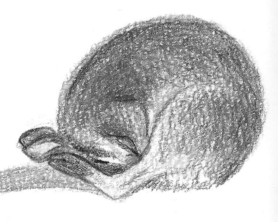

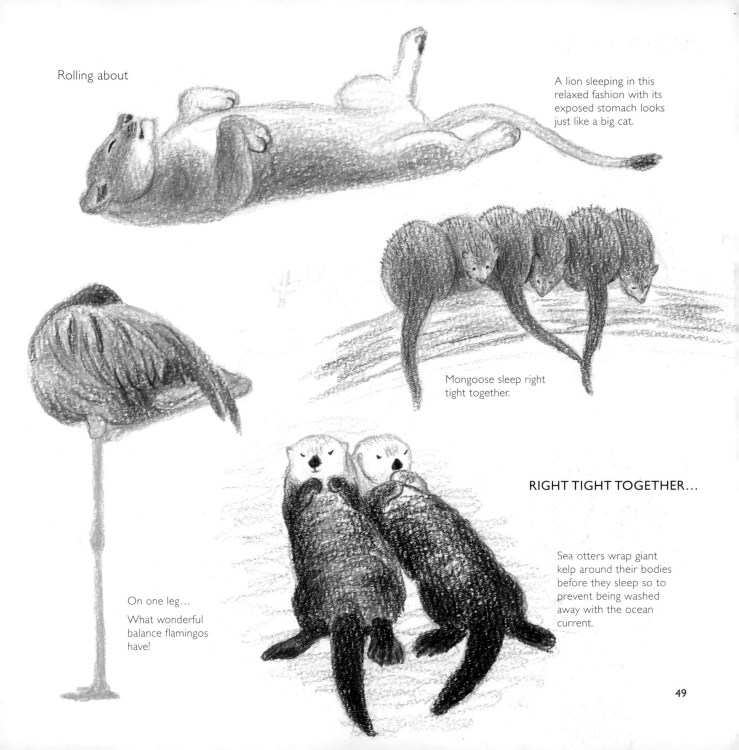

Rolling about

A lion sleeping in this relaxed fashion with its exposed stomach looks just like a big cat.

Mongoose sleep right tight together.

On one leg…
What wonderful balance flamingos have!

RIGHT TIGHT TOGETHER…

Sea otters wrap giant kelp around their bodies before they sleep so to prevent being washed away with the ocean current.

49

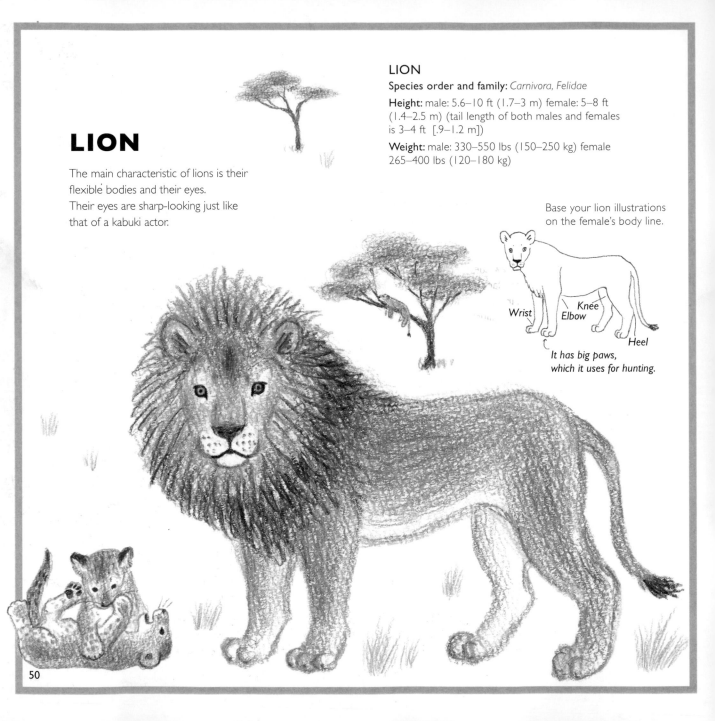

LION

The main characteristic of lions is their flexible bodies and their eyes.
Their eyes are sharp-looking just like that of a kabuki actor.

LION

Species order and family: *Carnivora, Felidae*

Height: male: 5.6–10 ft (1.7–3 m) female: 5–8 ft (1.4–2.5 m) (tail length of both males and females is 3–4 ft [.9–1.2 m])

Weight: male: 330–550 lbs (150–250 kg) female 265–400 lbs (120–180 kg)

Base your lion illustrations on the female's body line.

Wrist

Knee

Elbow

Heel

It has big paws, which it uses for hunting.

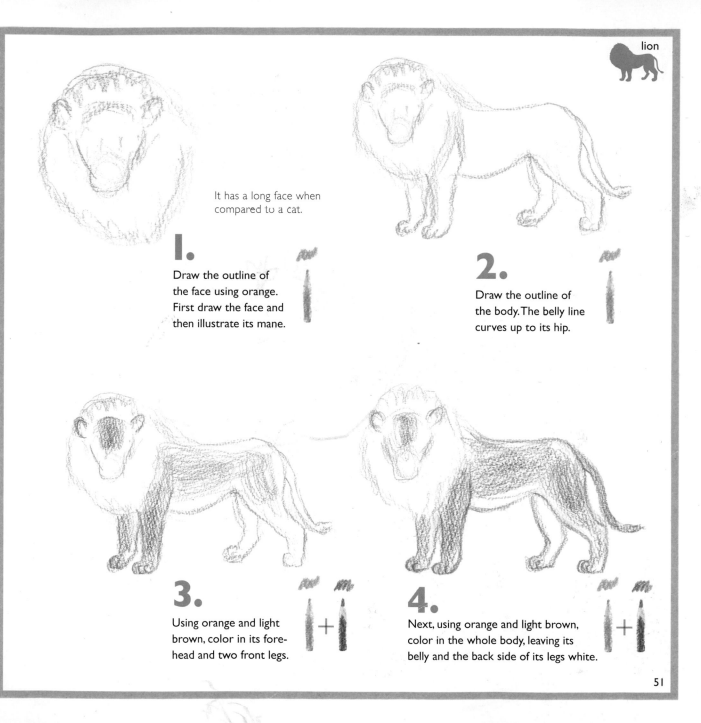

It has a long face when compared to a cat.

1.

Draw the outline of the face using orange. First draw the face and then illustrate its mane.

2.

Draw the outline of the body. The belly line curves up to its hip.

3.

Using orange and light brown, color in its forehead and two front legs.

4.

Next, using orange and light brown, color in the whole body, leaving its belly and the back side of its legs white.

51

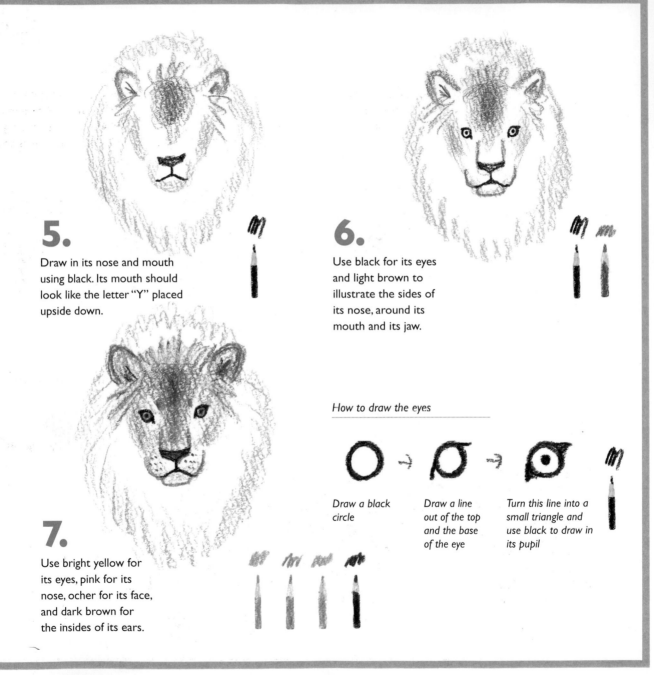

5.

Draw in its nose and mouth using black. Its mouth should look like the letter "Y" placed upside down.

6.

Use black for its eyes and light brown to illustrate the sides of its nose, around its mouth and its jaw.

7.

Use bright yellow for its eyes, pink for its nose, ocher for its face, and dark brown for the insides of its ears.

How to draw the eyes

Draw a black circle

Draw a line out of the top and the base of the eye

Turn this line into a small triangle and use black to draw in its pupil

8.

Draw its mane using light brown. Rough lines are fine at first.

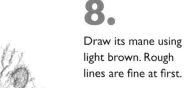

9.

Using ocher and light brown, increase the number of hairs on its mane and then, using the same colors, color in its body.

Females and cubs don't have a mane.

10.

Using ocher, light brown and dark brown, continue to color in its whole body. Using dark brown, highlight its mane. Use lots of dark brown to color in the underside of its mane. Use dark brown to illustrate the hairs on the tip of its tail.

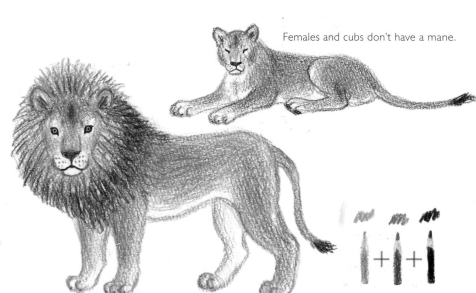

53

ALL KINDS OF CATS

CHEETAH

It has a beautiful and slender silhouette.

Species order and family: *Carnivora, Felidae*

Body Length: 4–5 ft (1.1–1.5 m)
(tail length is 2–3 ft [60–85 cm])

Weight: 45–155 lbs (20–70 kg)

OCELOT

The position of its eyes and nose are about the same as for domestic cats.

Species order and family: *Carnivora, Felidae*

Body Length: 22–40 in (55–100 cm) (tail length is 12–18 in [30–45 cm])

Weight: 24–35 lbs (11–16 kg)

TIGER

It has a relatively large head and paws

Species order and family: *Carnivora, F*

Body Length: 8–11 ft (2.4–3.3 m)

Weight: male: 400–680 lbs (180–310
female: 175–350 (80–160 kg)

SERVAL

It has ears that are the shape of a butterfly and long legs.

Species order and family:
Carnivora, Felidae

Body Length: 2–3 ft (70–100 cm)
(tail length is 12–18 in [30–45 cm])

Weight: 19–42 lbs (8.5–19 kg)

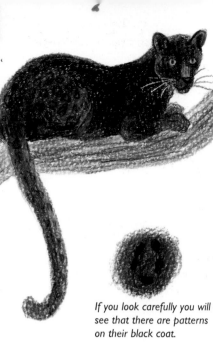

LEOPARD

They look so cute sprawled out and resting on a tree branch.

Species order and family:
Carnivora, Felidae

Body Length: 2–4 in (60–110 cm)

Weight: 66–200 lbs (30–90 kg)

If you look carefully you will see that there are patterns on their black coat.

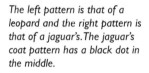

The left pattern is that of a leopard and the right pattern is that of a jaguar's. The jaguar's coat pattern has a black dot in the middle.

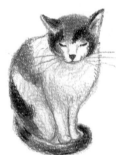

Of course, the Japanese cat is also a member of the Felidae family.

SNOW LEOPARD

Its legs are longer than other leopards' and they are much hairier.

Species order and family:
Carnivora, Felidae

Body Length: 3–5 ft (1–1.5 m)
(tail length is 31–40 in [80–100 cm])

Weight: 55–200 lbs (25–90 kg)

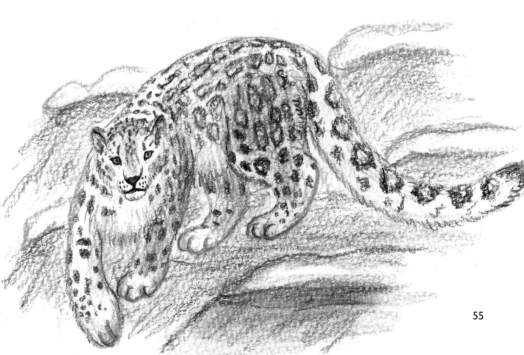

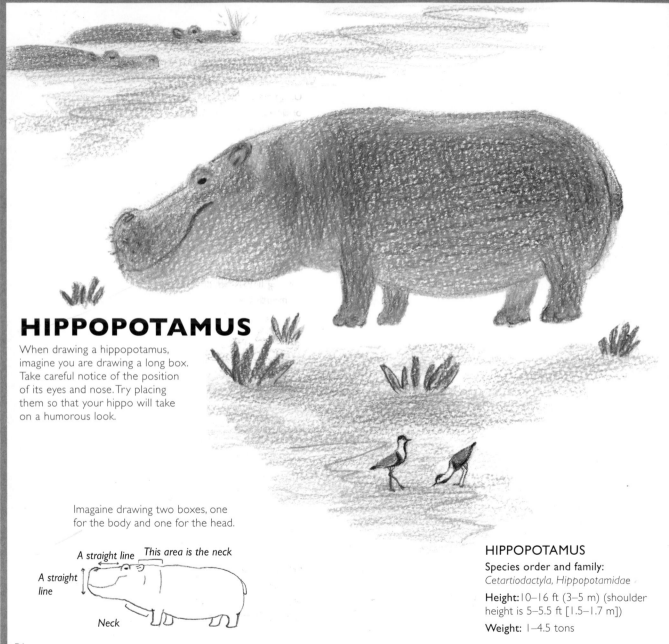

HIPPOPOTAMUS

When drawing a hippopotamus, imagine you are drawing a long box. Take careful notice of the position of its eyes and nose. Try placing them so that your hippo will take on a humorous look.

Imagaine drawing two boxes, one for the body and one for the head.

A straight line

This area is the neck

A straight line

Neck

HIPPOPOTAMUS

Species order and family:
Cetartiodactyla, Hippopotamidae

Height: 10–16 ft (3–5 m) (shoulder height is 5–5.5 ft [1.5–1.7 m])

Weight: 1–4.5 tons

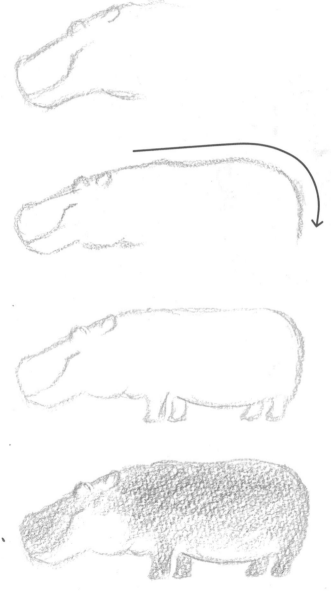

1.

Using ocher, draw the outline of its body. Draw a straight line from its eyes to its nose.

2.

Its back line should also be just about straight. For its buttock draw a slowly curving line. Next, draw its mouth line.

3.

Imagine you are drawing a long box with short stubs for its front and back feet.

4.

Holding your gray pencil horizontally to the paper, color in the body starting from the top.

57

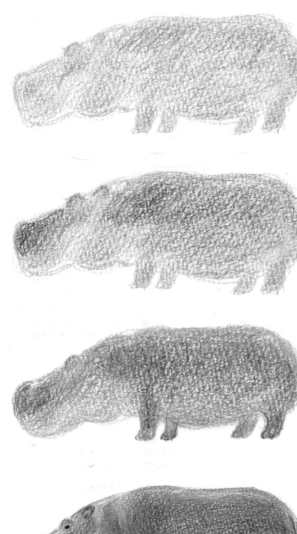

5.

Color in its eyes, throat, and belly using pink and orange.

6.

Using dark brown, color in the area around its nose and its back. Next, color the whole body pink.

7.

On top of the pink, dark gray, and dark brown add a layer of orange.

8.

Continue to overlay the colors. Finally, draw in the eyes using black and then the ears, mouth, hooves, and tail using dark brown.

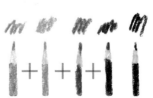

REVIEW OF THE SHAPE OF A HIPPOPOTAMUS

A hippopotamus' nose, eyes, and ears are all located on the same line.

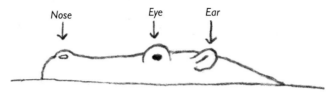

Nose *Eye* *Ear*

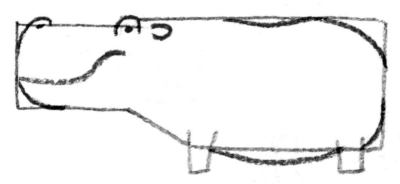

A hippopotamus' body line is shaped like a box. Round off the corners to make its body line.

You can open its mouth

Consider its head as one box and its body as another. By moving the head box in line with its neck, you can make various poses.

Or you can close its mouth and have it look down.

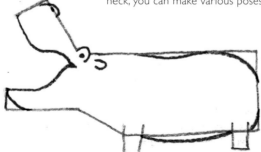

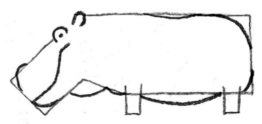

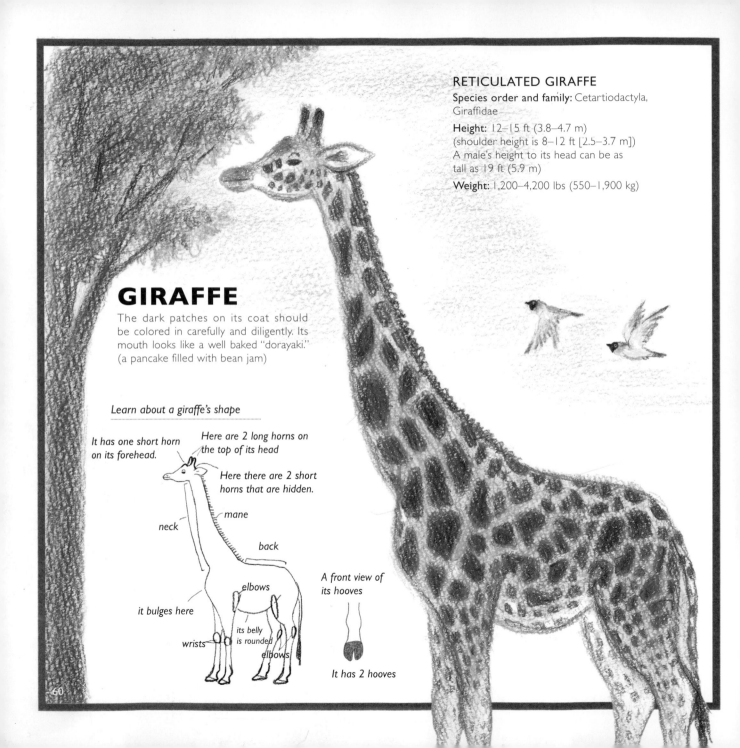

GIRAFFE

The dark patches on its coat should be colored in carefully and diligently. Its mouth looks like a well baked "dorayaki." (a pancake filled with bean jam)

RETICULATED GIRAFFE

Species order and family: Cetartiodactyla, Giraffidae

Height: 12–15 ft (3.8–4.7 m)
(shoulder height is 8–12 ft [2.5–3.7 m])
A male's height to its head can be as tall as 19 ft (5.9 m)

Weight: 1,200–4,200 lbs (550–1,900 kg)

Learn about a giraffe's shape

It has one short horn on its forehead.

Here are 2 long horns on the top of its head

Here there are 2 short horns that are hidden.

mane

neck

back

elbows

it bulges here

wrists

its belly is rounded

elbows

A front view of its hooves

It has 2 hooves

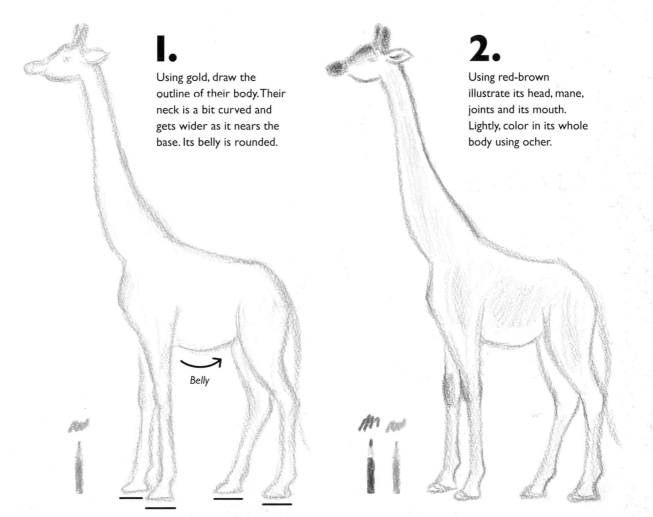

1.

Using gold, draw the outline of their body. Their neck is a bit curved and gets wider as it nears the base. Its belly is rounded.

Belly

Its hooves are flat with the ground.

2.

Using red-brown illustrate its head, mane, joints and its mouth. Lightly, color in its whole body using ocher.

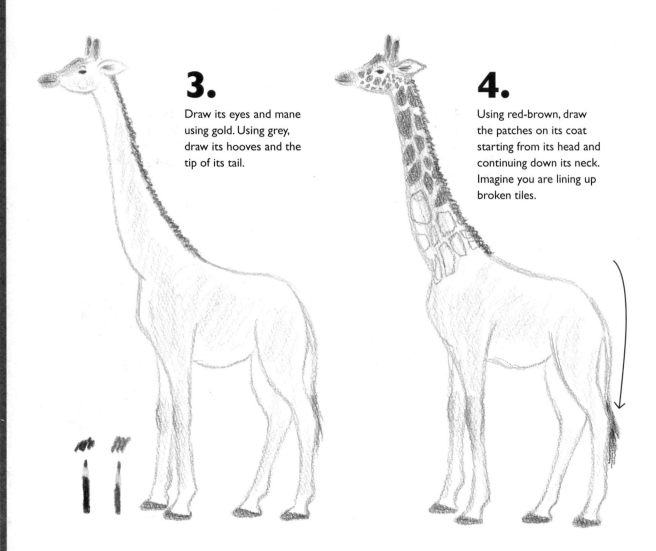

3.

Draw its eyes and mane using gold. Using grey, draw its hooves and the tip of its tail.

4.

Using red-brown, draw the patches on its coat starting from its head and continuing down its neck. Imagine you are lining up broken tiles.

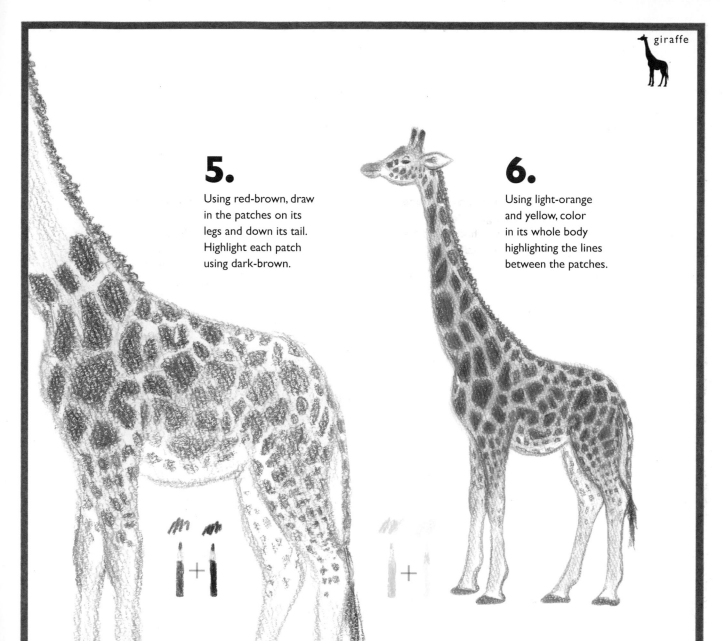

5.

Using red-brown, draw in the patches on its legs and down its tail. Highlight each patch using dark-brown.

6.

Using light-orange and yellow, color in its whole body highlighting the lines between the patches.

A LITTLE MORE ABOUT GIRAFFES

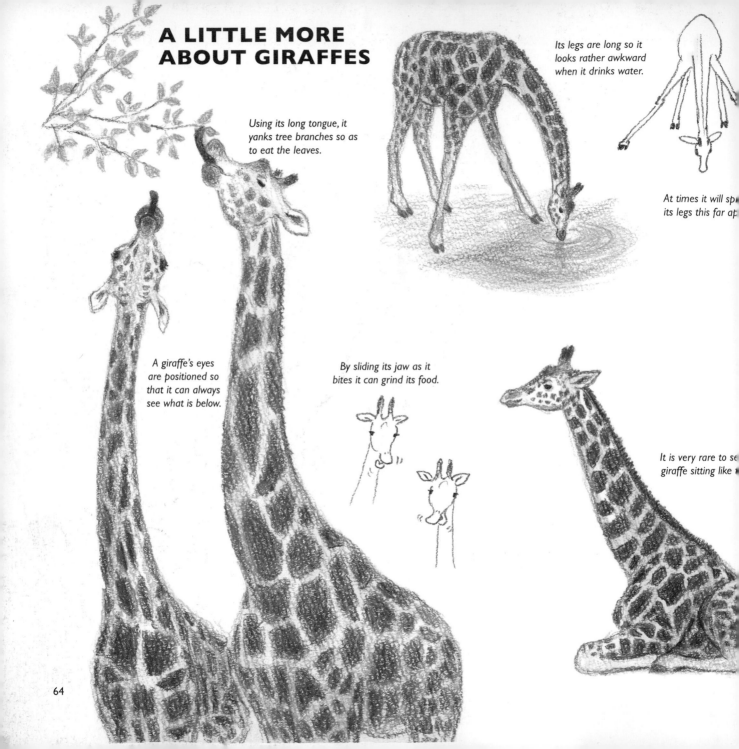

Using its long tongue, it yanks tree branches so as to eat the leaves.

Its legs are long so it looks rather awkward when it drinks water.

At times it will sp[...] its legs this far ap[...]

A giraffe's eyes are positioned so that it can always see what is below.

By sliding its jaw as it bites it can grind its food.

It is very rare to se[...] giraffe sitting like [...]

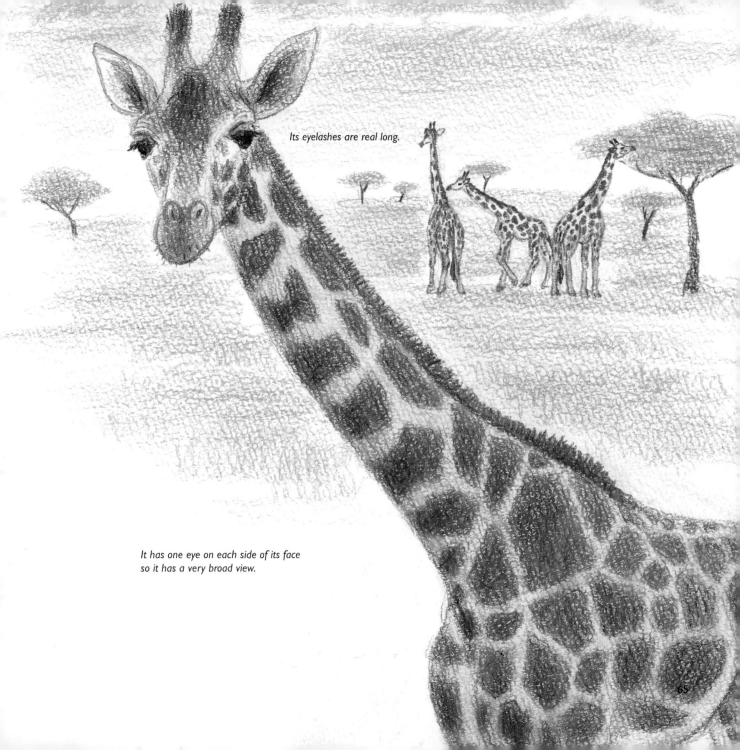

Its eyelashes are real long.

It has one eye on each side of its face
so it has a very broad view.

65

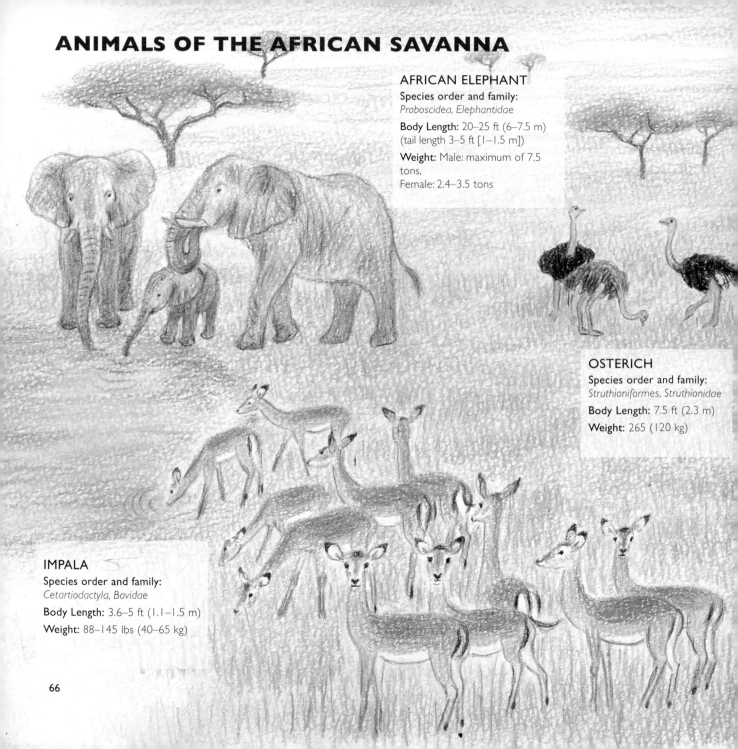

ANIMALS OF THE AFRICAN SAVANNA

AFRICAN ELEPHANT
Species order and family:
Proboscidea, Elephantidae

Body Length: 20–25 ft (6–7.5 m)
(tail length 3–5 ft [1–1.5 m])

Weight: Male: maximum of 7.5 tons,
Female: 2.4–3.5 tons

OSTERICH
Species order and family:
Struthioniformes, Struthionidae
Body Length: 7.5 ft (2.3 m)
Weight: 265 (120 kg)

IMPALA
Species order and family:
Cetartiodactyla, Bovidae
Body Length: 3.6–5 ft (1.1–1.5 m)
Weight: 88–145 lbs (40–65 kg)

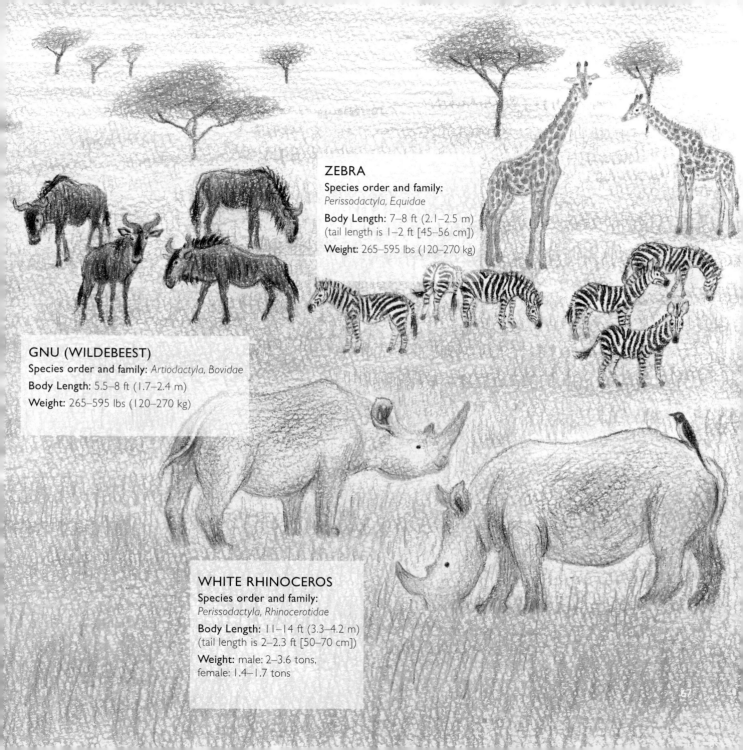

ZEBRA
Species order and family:
Perissodactyla, Equidae
Body Length: 7–8 ft (2.1–2.5 m)
(tail length is 1–2 ft [45–56 cm])
Weight: 265–595 lbs (120–270 kg)

GNU (WILDEBEEST)
Species order and family: *Artiodactyla, Bovidae*
Body Length: 5.5–8 ft (1.7–2.4 m)
Weight: 265–595 lbs (120–270 kg)

WHITE RHINOCEROS
Species order and family:
Perissodactyla, Rhinocerotidae
Body Length: 11–14 ft (3.3–4.2 m)
(tail length is 2–2.3 ft [50–70 cm])
Weight: male: 2–3.6 tons,
female: 1.4–1.7 tons

FOX

Foxes are often depicted in story tales, and their bushy tails are very charming. Their black feet make them look like they are wearing boots.

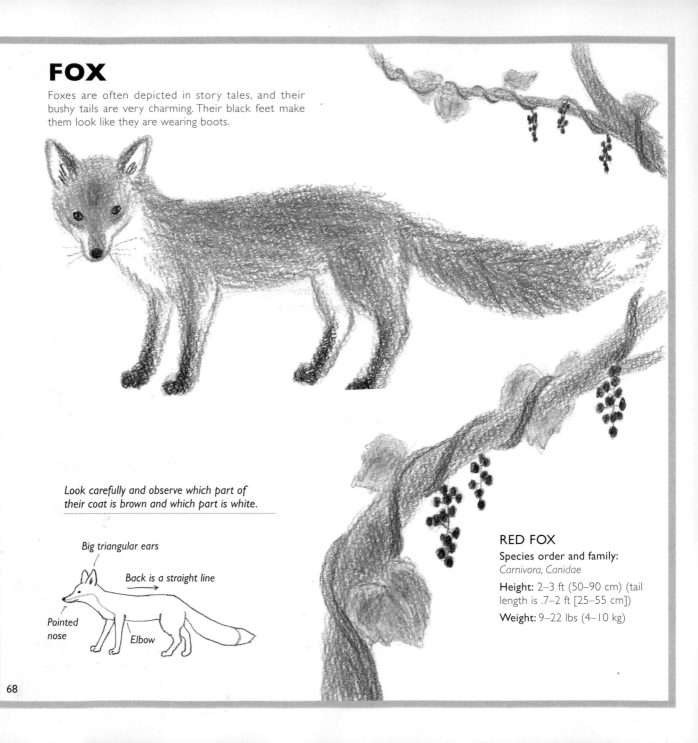

Look carefully and observe which part of their coat is brown and which part is white.

Big triangular ears

Back is a straight line

Pointed nose

Elbow

RED FOX
Species order and family: *Carnivora, Canidae*

Height: 2–3 ft (50–90 cm) (tail length is .7–2 ft [25–55 cm])

Weight: 9–22 lbs (4–10 kg)

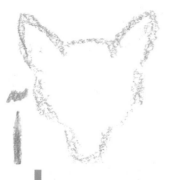

1.

Draw the outline of its face with ocher. First draw its ears and then its cheeks. Next, draw its pointed nose.

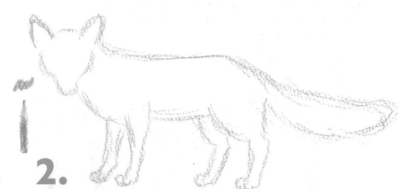

2.

Using ocher draw its back, chest, feet, and belly.

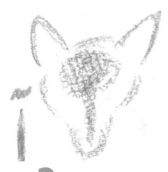

3.

Color in its body, starting from its face. Color in its forehead and then its nose ridge.

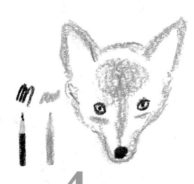

4.

Using black, draw in its eyes and nose. Now, using ocher, draw lines below both eyes to define the area you will leave white.

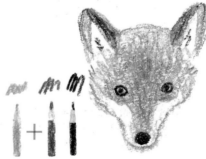

5.

Color in the face, according to the flow of its fur, using ocher and red-brown. So as to give the face some depth, color in the forehead and nose ridge forcefully. Add some black to the ears.

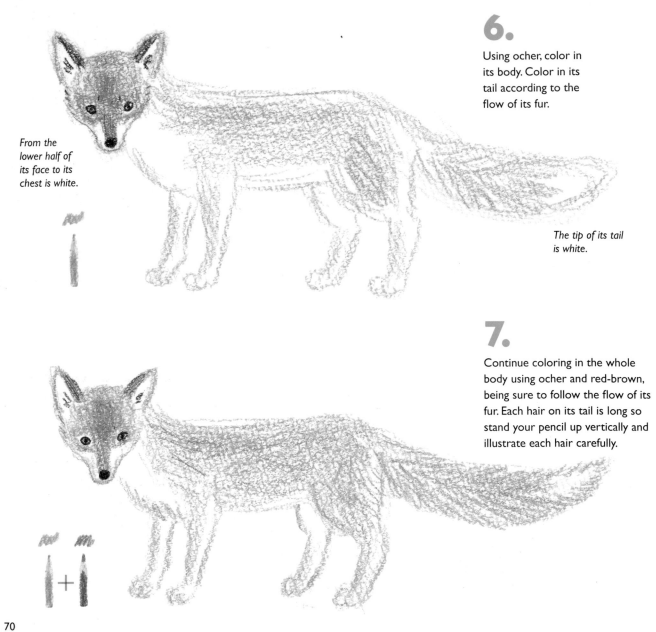

6.

Using ocher, color in its body. Color in its tail according to the flow of its fur.

From the lower half of its face to its chest is white.

The tip of its tail is white.

7.

Continue coloring in the whole body using ocher and red-brown, being sure to follow the flow of its fur. Each hair on its tail is long so stand your pencil up vertically and illustrate each hair carefully.

8.

Using black, color in the front parts of its legs.

9.

Layer your colors using ocher, red-brown, and gray. Finally, illustrate its whiskers.

ALL KINDS OF DOGS

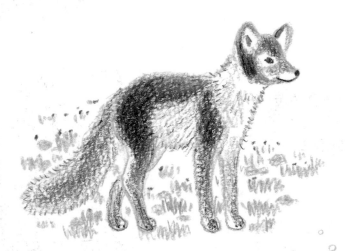

WOLF

Drawing a howling wolf by making its long mouth a bit short, will make it look cute.

Species order and family:
Carnivora, Canidae

Body Length: 3–5 ft. (1–1.5 m)
(tail length is 1–2 ft [30–55 cm])

Weight: 44–176 lbs (20–80 kg)

ARCTIC FOX

During the summer they become a sleek silver color. Then in winter they become a fluffy white.

Species order and family:
Carnivora, Canidae

Body Length: 1.5–2 ft (46–68 cm)
(tail length is .8–1.4 ft [26–13 cm])

Weight: 6–20 lbs (2.5–9 kg)

FENNEC FOX

They have very big ears and their coat is a brilliant yellow.

Species order and family:
Carnivora, Canidae

Body Length: .8–1.3 ft (25–40 cm)
(tail length is .8–1.8 ft in [25–55 cm])

Weight: 9–22 lbs (4–10 kg)

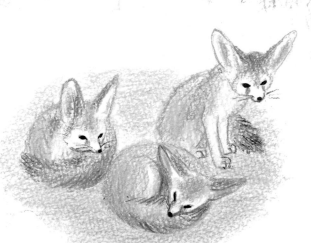

LYCAON

They have big round ears and their coat is spotted with three colors.

Species order and family: *Carnivora, Canidae*
Body Length: 2.5–3.6 ft (tail length is 1–1.3 ft [30–50 cm])
Weight: 44–77 lbs (20–35 kg)

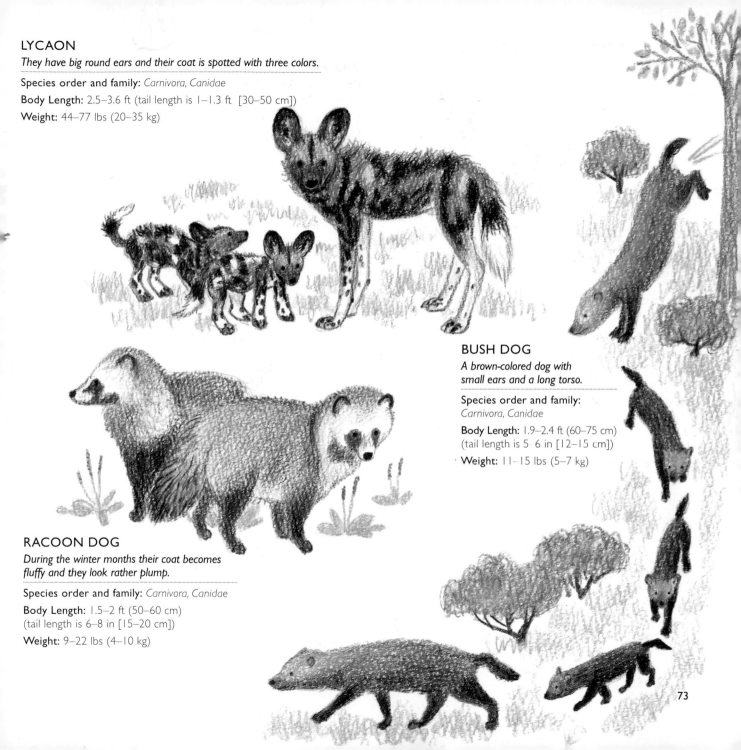

BUSH DOG

A brown-colored dog with small ears and a long torso.

Species order and family: *Carnivora, Canidae*
Body Length: 1.9–2.4 ft (60–75 cm) (tail length is 5–6 in [12–15 cm])
Weight: 11–15 lbs (5–7 kg)

RACOON DOG

During the winter months their coat becomes fluffy and they look rather plump.

Species order and family: *Carnivora, Canidae*
Body Length: 1.5–2 ft (50–60 cm) (tail length is 6–8 in [15–20 cm])
Weight: 9–22 lbs (4–10 kg)

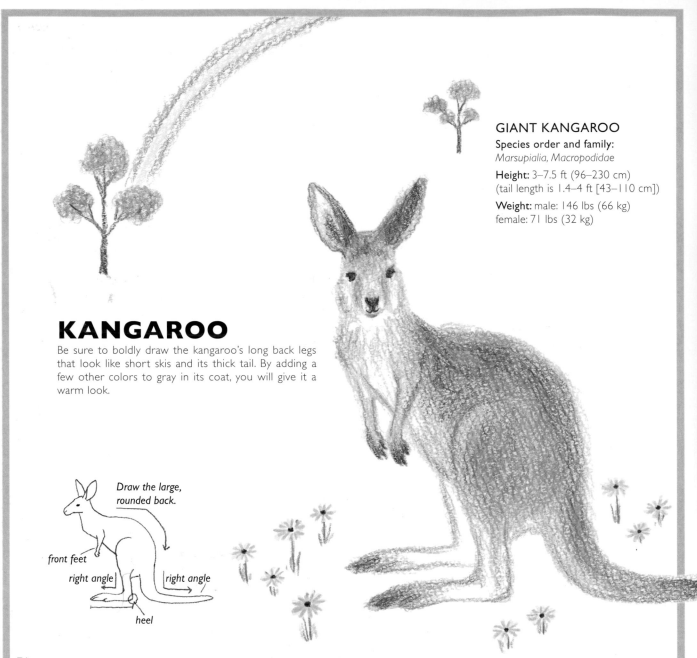

KANGAROO

Be sure to boldly draw the kangaroo's long back legs that look like short skis and its thick tail. By adding a few other colors to gray in its coat, you will give it a warm look.

GIANT KANGAROO
Species order and family:
Marsupialia, Macropodidae
Height: 3–7.5 ft (96–230 cm)
(tail length is 1.4–4 ft [43–110 cm])
Weight: male: 146 lbs (66 kg)
female: 71 lbs (32 kg)

Draw the large, rounded back.

front feet

right angle

right angle

heel

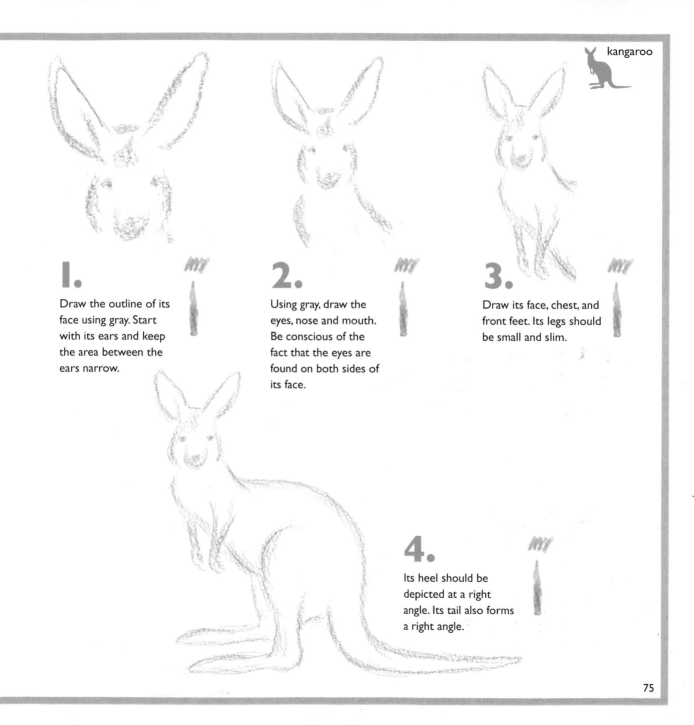

1.

Draw the outline of its face using gray. Start with its ears and keep the area between the ears narrow.

2.

Using gray, draw the eyes, nose and mouth. Be conscious of the fact that the eyes are found on both sides of its face.

3.

Draw its face, chest, and front feet. Its legs should be small and slim.

4.

Its heel should be depicted at a right angle. Its tail also forms a right angle.

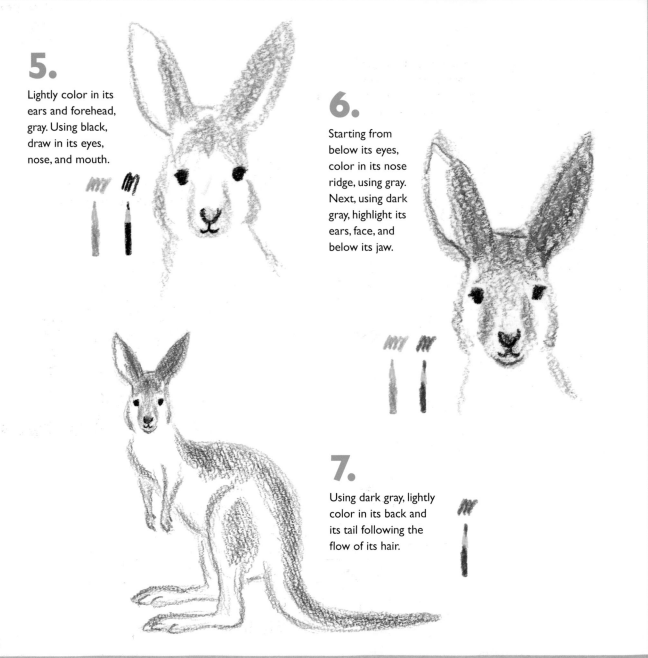

5.

Lightly color in its ears and forehead, gray. Using black, draw in its eyes, nose, and mouth.

6.

Starting from below its eyes, color in its nose ridge, using gray. Next, using dark gray, highlight its ears, face, and below its jaw.

7.

Using dark gray, lightly color in its back and its tail following the flow of its hair.

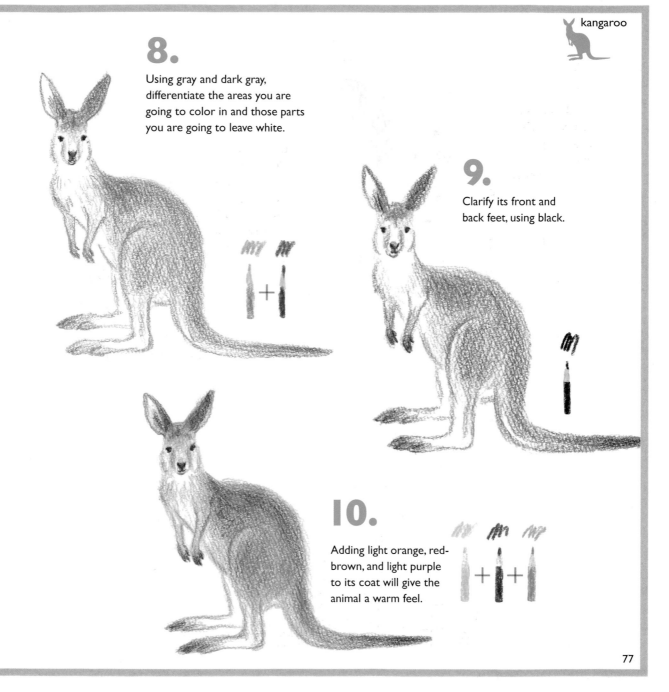

8.

Using gray and dark gray, differentiate the areas you are going to color in and those parts you are going to leave white.

9.

Clarify its front and back feet, using black.

10.

Adding light orange, red-brown, and light purple to its coat will give the animal a warm feel.

ANIMALS OF AUSTRALIA

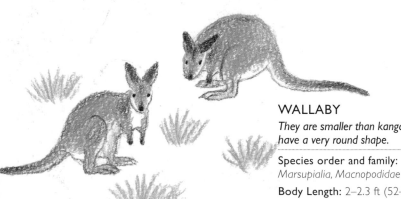

WALLABY
They are smaller than kangaroos and have a very round shape.

Species order and family: *Marsupialia, Macnopodidae*

Body Length: 2–2.3 ft (52–68 cm) (tail length is 1–1.4 ft [30–45 cm])

Weight: 9–22 lbs (4–10 kg)

DENDROLAGUS GOODFELLOWI
Its coat is a two-toned color and the colors are the same as a "castella" sponge cake.

Species order and family: *Marsupialia, Macnopodidae*

Body Length: 2–2.5 ft (60–75 cm) (tail length is 31 in [80 cm])

Weight: 18 lbs (8 kg)

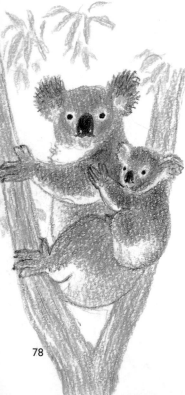

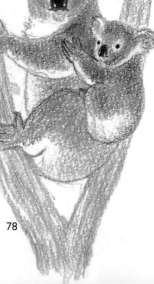

KOALA
Please note that the fingers on their front paws are separated into two fingers and three fingers.

Species order and family: *Marsupialia, Phascolarctidae*

Body Length: 2.3–2.5 ft (72–78 cm)

Weight: male: 26 lbs (12 kg) female: 18 lbs (8 kg)

WOMBAT
They have a big head and look rather plump

Species order and family: *Diprotodontia, Vombatidae*

Body Length: 2.5–3 ft (77–93 cm) (tail length is .08–.1 in [2.5–6 cm])

Weight: 19–42 (8.5–19 kg)

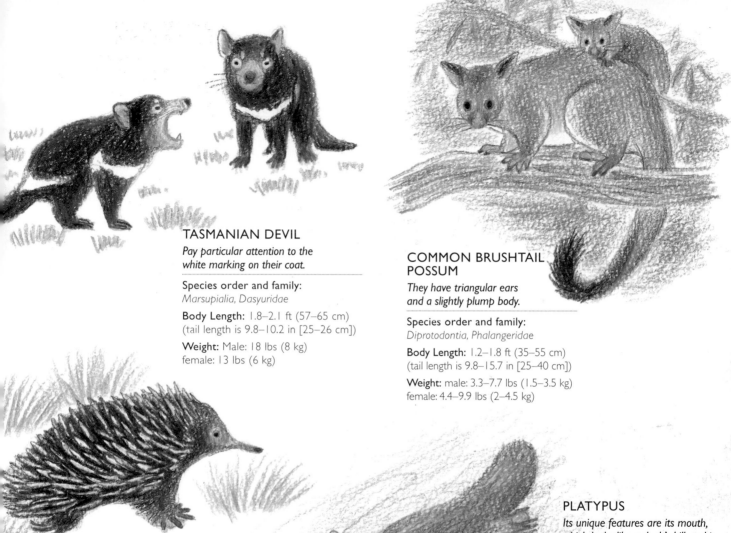

TASMANIAN DEVIL

*Pay particular attention to the
white marking on their coat.*

Species order and family:
Marsupialia, Dasyuridae

Body Length: 1.8–2.1 ft (57–65 cm)
(tail length is 9.8–10.2 in [25–26 cm])

Weight: Male: 18 lbs (8 kg)
female: 13 lbs (6 kg)

COMMON BRUSHTAIL POSSUM

*They have triangular ears
and a slightly plump body.*

Species order and family:
Diprotodontia, Phalangeridae

Body Length: 1.2–1.8 ft (35–55 cm)
(tail length is 9.8–15.7 in [25–40 cm])

Weight: male: 3.3–7.7 lbs (1.5–3.5 kg)
female: 4.4–9.9 lbs (2–4.5 kg)

ECHIDNA

*Its unique characteristic is its thin
and pointed nose and its sharp claws.*

Species order and family:
Monotremata, Tachyglossidae

Body Length: 1.2–1.8 ft (35–53 cm)

Weight: 5.5–15 lbs (2.5–7 kg)

PLATYPUS

*Its unique features are its mouth,
which looks like a duck's bill, and its
webbed feet.*

Species order and family:
Monotremata, Ornithorhynchidae

Body Length: 1–1.5 ft (30–45 cm)
(tail length is 4–6 in [10–15 cm])

Weight: 1–4 lbs (0.5–2 kg)

WHOSE BUM?

Answers: 1. Rabbit 2. Hippopotamus 3. Hedgehog 4. Zebra 5. Badger 6. Deer 7. Malayan tapir 8. Polar bear 9. Squirrel 10. Alpaca 11. Pig 12. Ring-tailed lemur

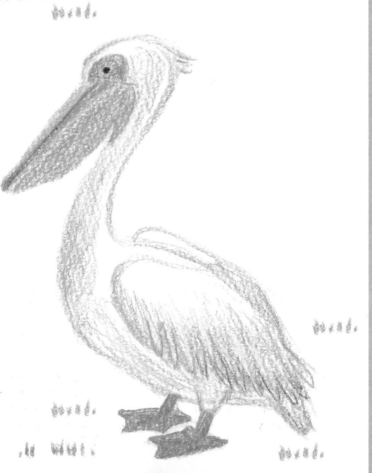

PINK PELICAN
Species order and family :
Pelecaniformes, Pelecanidae
Height: 4.5–5.5 ft (140–170 cm)
(bill length is 1.5 ft [45 cm])
Weight: 22 lbs (10 kg)

PELICAN

A pelican's body line is like a pear. Imagine you are drawing the letter "S." Please note that it has a brilliant line of light blue along its bill.

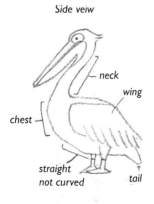

Side veiw

chest

neck

wing

straight
not curved

tail

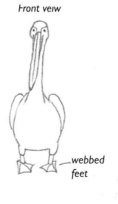

Front veiw

webbed
feet

1.

Draw an outline of the face using gray. Start from under the bill, neck, and chest.

Does this line look like a backward "S"?

2.

Carefully draw its beak, the lines around its eyes, and its wing. Don't forget to illustrate the decorative feathers on the top of its head.

3.

Boldly color in the area under its beak bright yellow. Also, one part of its chest should have some bright yellow.

4.

Using pink and bright yellow, color in the area around its eyes and then its feet. Next, give the whole body a shade of pink.

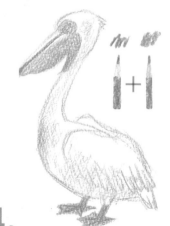

5.

Draw in its eyes using black. Using light blue and purple, draw a line between its upper and lower beak.

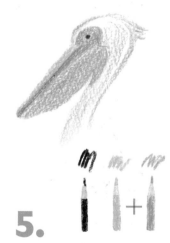

PENGUIN

Everyone adores this bird that waddles on the ice. Pink on its monotone-colored body makes for a great contrast. Be careful to leave the white circles around its eyes.

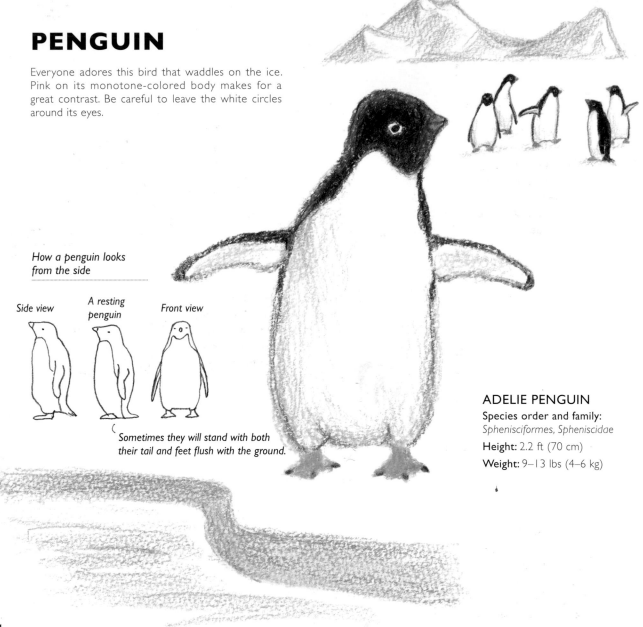

How a penguin looks from the side

Side view

A resting penguin

Front view

Sometimes they will stand with both their tail and feet flush with the ground.

ADELIE PENGUIN

Species order and family: *Sphenisciformes, Spheniscidae*

Height: 2.2 ft (70 cm)

Weight: 9–13 lbs (4–6 kg)

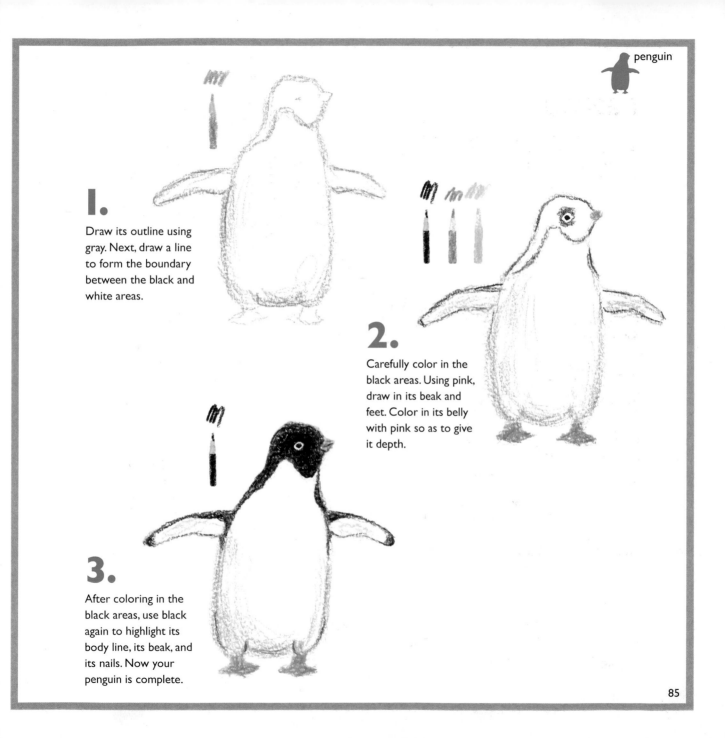

1.

Draw its outline using gray. Next, draw a line to form the boundary between the black and white areas.

2.

Carefully color in the black areas. Using pink, draw in its beak and feet. Color in its belly with pink so as to give it depth.

3.

After coloring in the black areas, use black again to highlight its body line, its beak, and its nails. Now your penguin is complete.

85

COMPARING PENGUINS

120
110
100
90
80
70
60
50
40
30
20
10
0

40 cm~
(15.7 in)

57cm~
(22.4 in)

63 cm~
(24.8 in)

69 cm~
(27.1 in)

70 cm~
(27.6 in)

FAIRY PENGUIN

Its back is a bluish-gray color and its feet are pink

Species order and family: *Sphenisciformes, Spheniscidae*

Body Length: 1.3 ft (40 cm)

Weight: 1.3–3.1 lbs (0.6–1.4 kg)

ROCKHOPPER PENGUIN

They have yellow feathers that stand straight up.

Species order and family: *Sphenisciformes, Spheniscidae*

Body Length: 1.9–2.1 ft (57–65 cm)

Weight: 5.5–7.7 lbs (2.5–3.5 kg)

AFRICAN PENGUIN

They have a black line running from their chest down to their fore flank.

Species order and family: *Sphenisciformes, Spheniscidae*

Body Length: 2.1 ft (63 cm)

Weight: 6.6–7.9 lbs (3–3.6 kg)

CHINSTRAP PENGUIN

They have a thin black line under their chin.

Species order and family: *Sphenisciformes, Spheniscidae*

Body Length: 2.3–2.5 ft (69–76 cm)

Weight: 7.5–11 lbs (3.4–5 kg)

ADELIE PENGUIN

They have a white ring around their eyes and the back end of their head is a little pointed.

Species order and family: *Sphenisciformes, Spheniscidae*

Body Length: 2.2 ft (70 cm)

Weight: 9–13 lbs (4–6 kg)

71 cm~
(28 in)

85 cm~
(33.5 in)

100 cm~
(39.4 in)

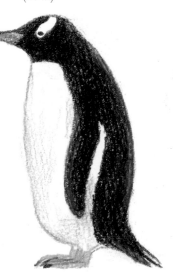

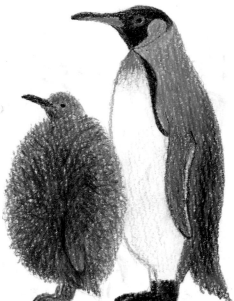

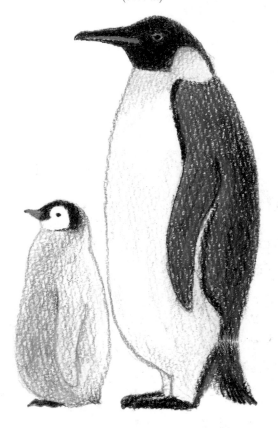

GENTOO PENGUIN

The white line on top of their head looks like a headband.

Species order and family: *Sphenisciformes, Spheniscidae*

Body Length: 2.3–2.5 ft (71–75 cm)

Weight: 11–12 lbs (5–5.5 kg)

KING PENGUIN

Their chicks are covered with fluffy brown feathers.

Species order and family: *Sphenisciformes, Spheniscidae*

Body Length: 2.8–3.1 ft (85–95 cm)

Weight: 26–31 lbs (12–14 kg)

EMPEROR PENGUIN

Put simply, they are a big penguin.

Species order and family: *Sphenisciformes, Spheniscidae*

Body Length: 3.3–4.3 ft (100–130 cm)

Weight: 66–84 lbs (30–38 kg)

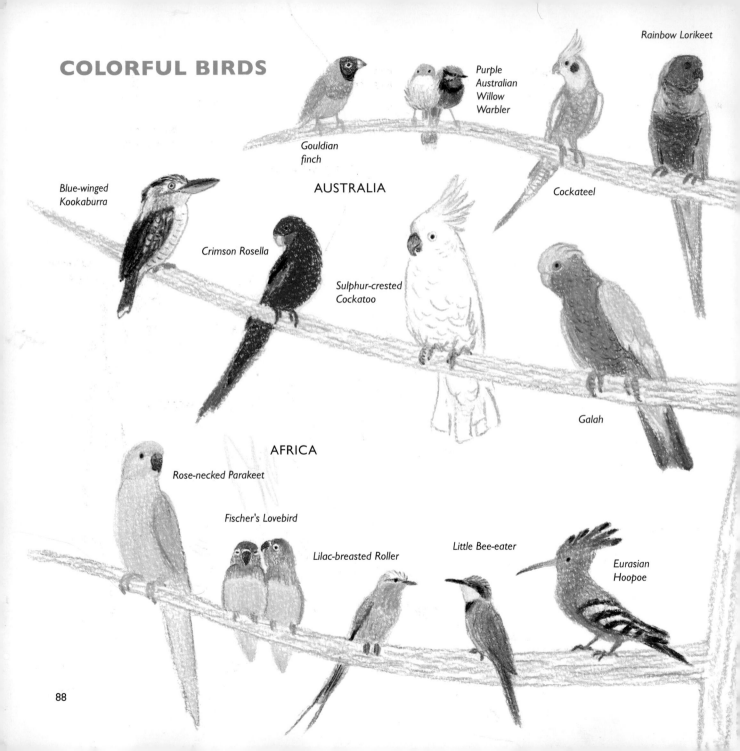

COLORFUL BIRDS

Rainbow Lorikeet

Purple Australian Willow Warbler

Gouldian finch

AUSTRALIA

Cockateel

Blue-winged Kookaburra

Crimson Rosella

Sulphur-crested Cockatoo

Galah

AFRICA

Rose-necked Parakeet

Fischer's Lovebird

Lilac-breasted Roller

Little Bee-eater

Eurasian Hoopoe

88

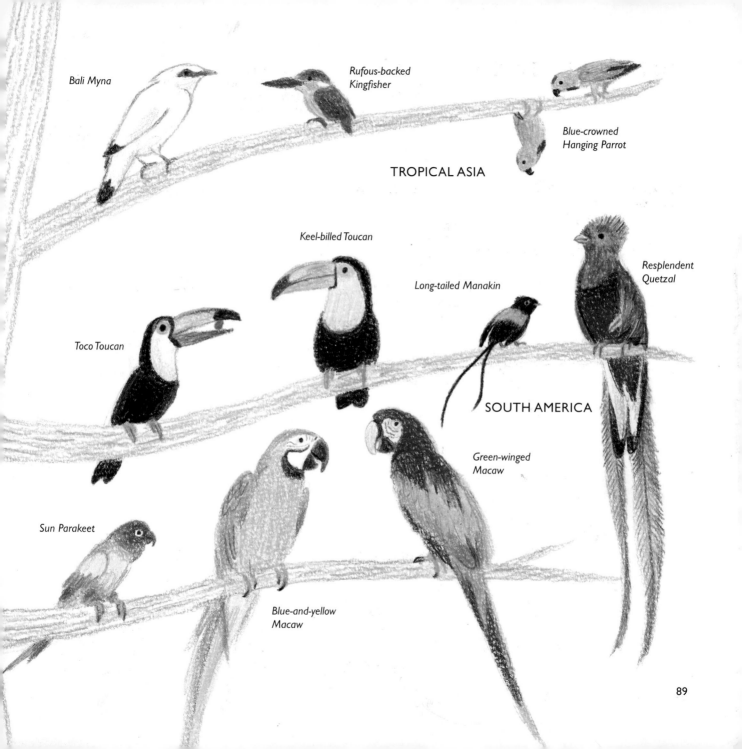

Bali Myna

Rufous-backed
Kingfisher

Blue-crowned
Hanging Parrot

TROPICAL ASIA

Keel-billed Toucan

Long-tailed Manakin

Resplendent
Quetzal

Toco Toucan

SOUTH AMERICA

Green-winged
Macaw

Sun Parakeet

Blue-and-yellow
Macaw

89

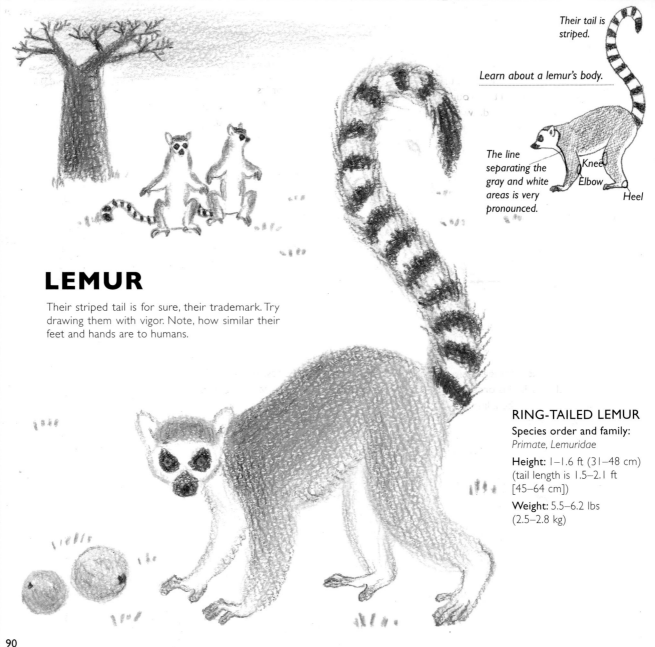

Their tail is striped.

Learn about a lemur's body.

The line separating the gray and white areas is very pronounced.

Knee

Elbow

Heel

LEMUR

Their striped tail is for sure, their trademark. Try drawing them with vigor. Note, how similar their feet and hands are to humans.

RING-TAILED LEMUR

Species order and family:
Primate, Lemuridae

Height: 1–1.6 ft (31–48 cm)
(tail length is 1.5–2.1 ft
[45–64 cm])

Weight: 5.5–6.2 lbs
(2.5–2.8 kg)

1.

Draw the outline of its head using gray. Its ears should be a rounded triangular shape. Also draw the line of its coat pattern.

2.

For its neck, back, and hip, draw a line that curves upward.

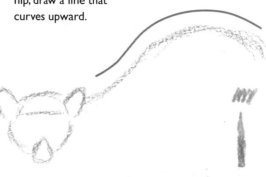

3.

Next, draw its front legs, belly, and back legs, in this order. Its belly should also be a line that curves upwards.

This is the characteristic line.

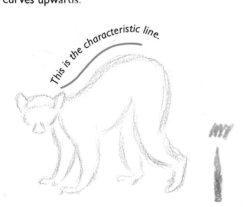

4.

Draw the letter "S" to depict its long tail.

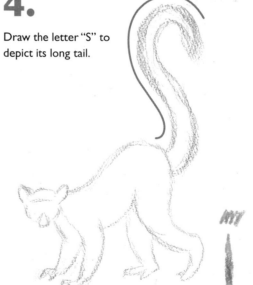

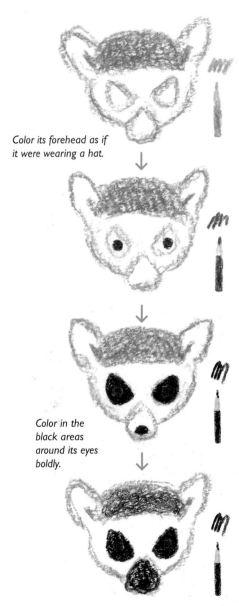

Color its forehead as if it were wearing a hat.

Color in the black areas around its eyes boldly.

5.

Use gray to illustrate its face, red-brown for its eyes, and black for around its eyes and around its nose.

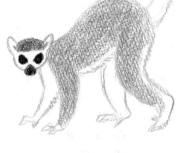

6.

Using gray, color in its front legs, back, and back legs. The underside of its body is white.

Color from its chest to its back, a red-brown color.

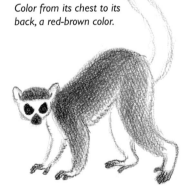

7.

Add red and gray to its back. Highlight its fingers and toes using black.

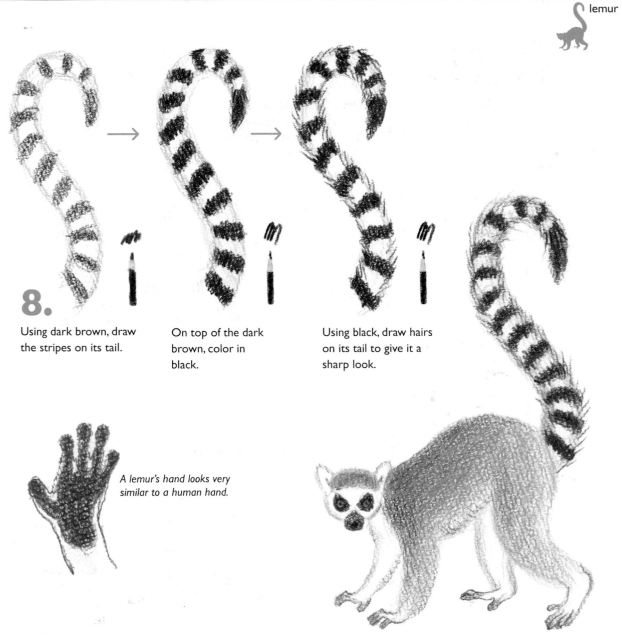

8.

Using dark brown, draw the stripes on its tail.

On top of the dark brown, color in black.

Using black, draw hairs on its tail to give it a sharp look.

A lemur's hand looks very similar to a human hand.

ALL KINDS OF MONKEYS

ORANGUTAN

Draw in its sparse hairs using red-brown so that its flesh can still be seen.

Species order and family:
Primates, Hominidae

Body Length: male: approx. 3.2 ft (97 cm)
female: approx. 2.6 ft (78 cm)

Weight: male: approx. 172–181 lbs (78–82 kg)

female: approx. 82 lbs (37 kg)

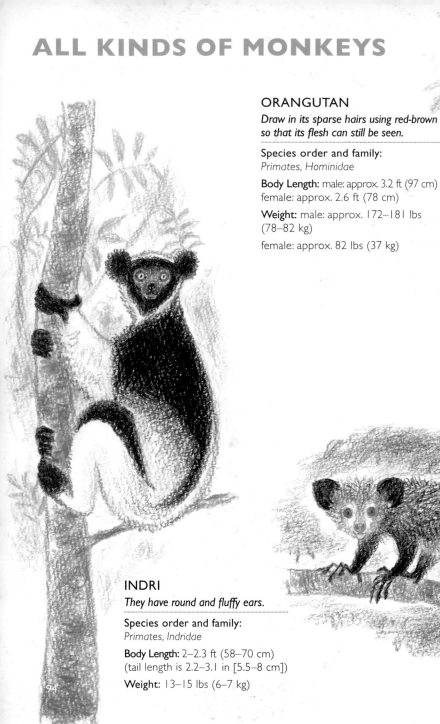

INDRI

They have round and fluffy ears.

Species order and family:
Primates, Indridae

Body Length: 2–2.3 ft (58–70 cm)
(tail length is 2.2–3.1 in [5.5–8 cm])

Weight: 13–15 lbs (6–7 kg)

AYE-AYE

They have a unique coat that ha_ white hairs mixed with dark hair_ Their tails are very bushy.

Species order and family:
Primates, Daubentoniidae

Body Length: 1.3 ft (40 cm)
(tail length 1.3 ft [40 cm])

Weight: 5.7–6.2 lbs (2.6–2.8 k_

94

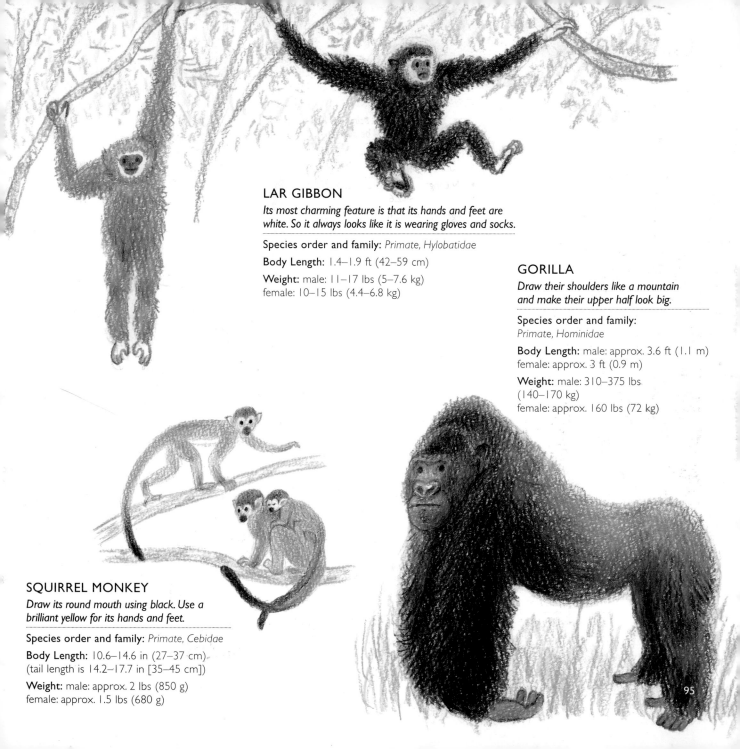

LAR GIBBON

Its most charming feature is that its hands and feet are white. So it always looks like it is wearing gloves and socks.

Species order and family: *Primate, Hylobatidae*

Body Length: 1.4–1.9 ft (42–59 cm)

Weight: male: 11–17 lbs (5–7.6 kg)
female: 10–15 lbs (4.4–6.8 kg)

GORILLA

Draw their shoulders like a mountain and make their upper half look big.

Species order and family:
Primate, Hominidae

Body Length: male: approx. 3.6 ft (1.1 m)
female: approx. 3 ft (0.9 m)

Weight: male: 310–375 lbs
(140–170 kg)
female: approx. 160 lbs (72 kg)

SQUIRREL MONKEY

Draw its round mouth using black. Use a brilliant yellow for its hands and feet.

Species order and family: *Primate, Cebidae*

Body Length: 10.6–14.6 in (27–37 cm)
(tail length is 14.2–17.7 in [35–45 cm])

Weight: male: approx. 2 lbs (850 g)
female: approx. 1.5 lbs (680 g)

95

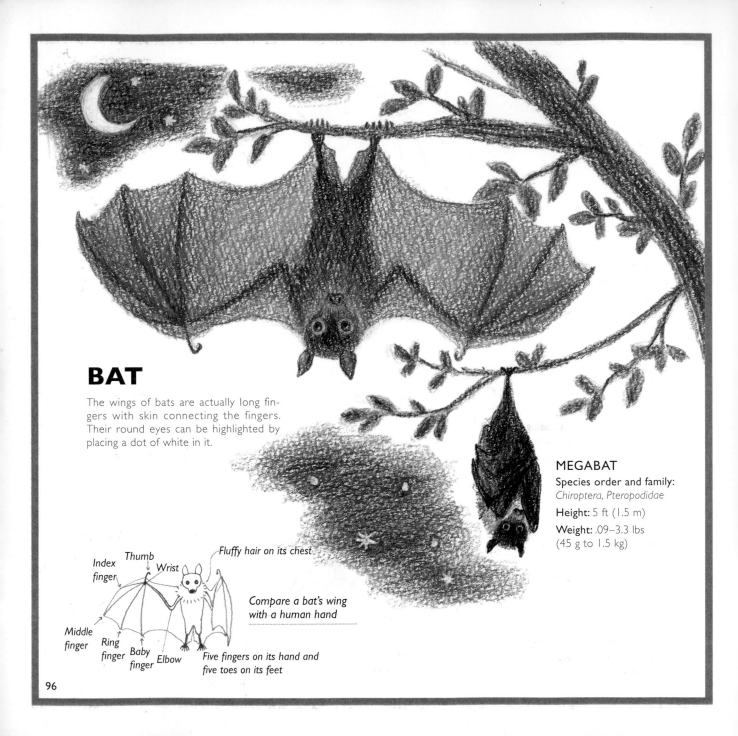

BAT

The wings of bats are actually long fingers with skin connecting the fingers. Their round eyes can be highlighted by placing a dot of white in it.

MEGABAT

Species order and family:
Chiroptera, Pteropodidae

Height: 5 ft (1.5 m)

Weight: .09–3.3 lbs (45 g to 1.5 kg)

Index finger
Thumb
Wrist
Fluffy hair on its chest
Middle finger
Ring finger
Baby finger
Elbow

Compare a bat's wing with a human hand

Five fingers on its hand and five toes on its feet

96

It is easiest if you illustrate them upside down.

1.

Using dark brown, draw the outline of their body. For their head, imagine you are drawing a fox's head.

2.

It has five fingers. The first finger is shaped like a hook.

3.

Connect the fingers to form the wing.

4.

Draw its hands and feet using black. Use ocher to color in its chest. Use gray to draw its ears and nose.

First draw the eyes using a light color.

5.

Color in its head and body using a gradation of brown. Its wing should have a fluffy feel to it. Color in its chest using brighter browns. For its wing, hold your pencil horizontally to the paper and give it a warm feel.

bright colors

dark colors

bright yellow + *light brown* + *red-brown*

dark brown + *purple* + *black*

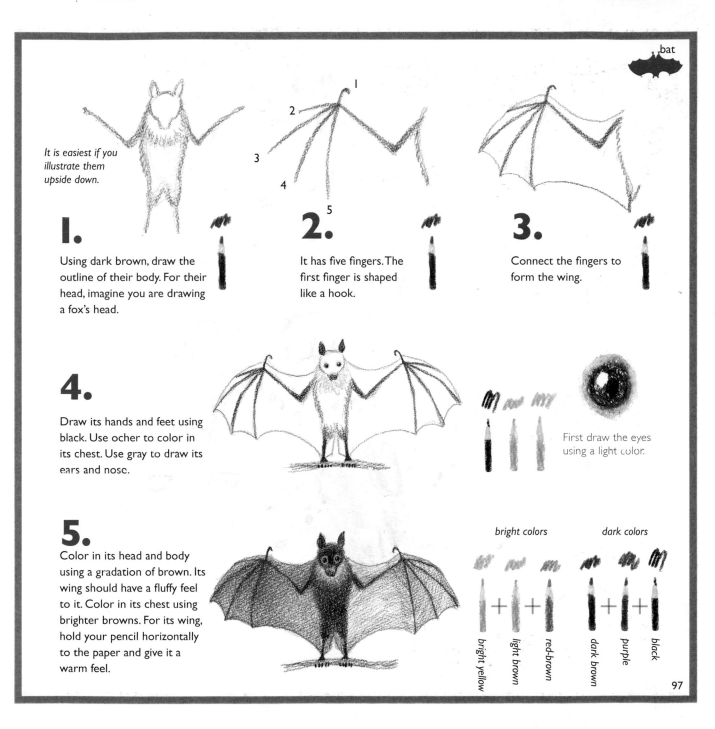

97

NIGHTTIME

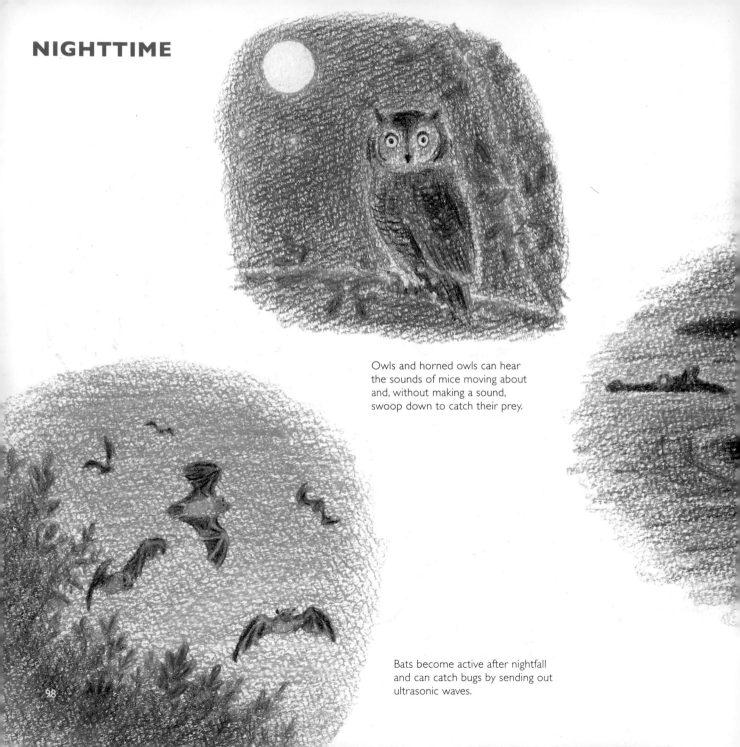

Owls and horned owls can hear the sounds of mice moving about and, without making a sound, swoop down to catch their prey.

Bats become active after nightfall and can catch bugs by sending out ultrasonic waves.

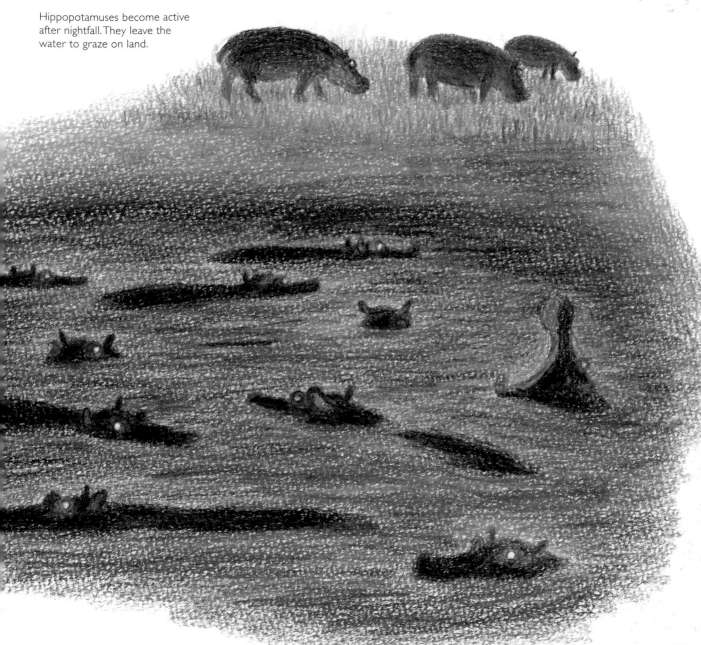

Hippopotamuses become active after nightfall. They leave the water to graze on land.

NEW YEAR'S CARDS WITH ANIMALS

Drawing new year's cards with colored pencils is a rather time consuming effort , however, the person receiving your card will no doubt be very impressed. When drawing many new year's cards at once, it is advised that instead of using the colored pencils you have on hand and layering your colors, you should go to an art suppy store and purchase the exact colors you want. At most stores you can buy each color separately. Such art suppy stores will also sell postcard-sized paper. Here, I used water-coloring perforated paper which could be made into a postcard size. Imagine the animal you are going to illustrate first, and then choose the colored pencils and paper you want to use.

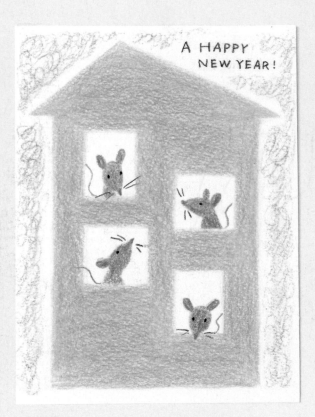

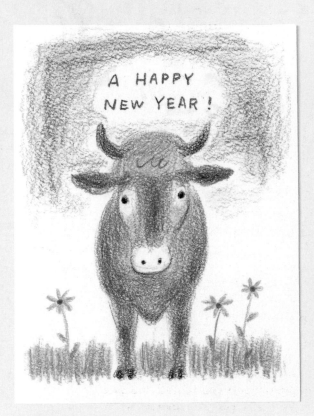

MOUSE

Here are some mice which live in a cheese house. Color in the yellow cheese uniformly and for the space around the house try using gray, making small and gentle circular motions.

COW

Here is a front view of a cute bull. Draw a bright blue sky and make it look like he is chewing his cud. Use red-brown and ocher and keep your illustration simple.

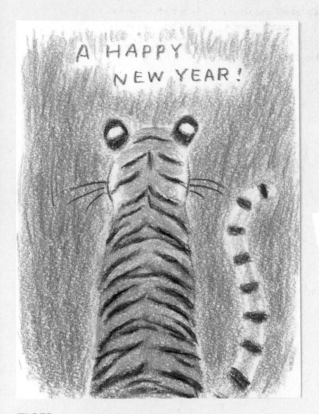

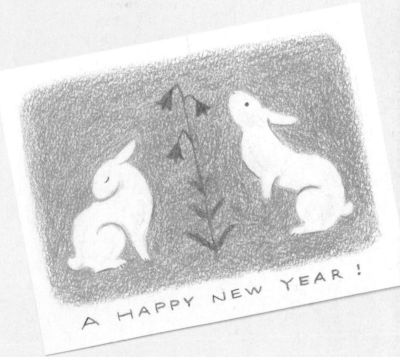

TIGER

Here is a tiger with a cute design on the back of its ears. What do you think of a back view of a tiger for a New Year's greeting card? When drawing its stripes, imagine where its backbone is and draw the stripes so that they spread out from that line.

RABBIT

By coloring the background a gentle pink you can make the whiteness of the rabbit stand out. Use soft lines for its body lines, and if you choose a color from your drawing to do the lettering, the card will have a more uniform look.

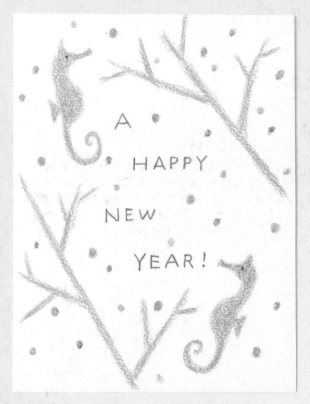

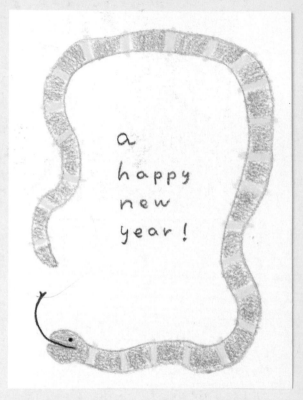

SEAHORSE

A polkadot design is good for expressing the excitement of New Year's Day. It should be fun to choose colors you like and make combinations of colors that appeal to you.

SNAKE

Use colors you like to draw a cute snake with a long tounge. You can use the white space inside the snake freely—to write a message, for example.

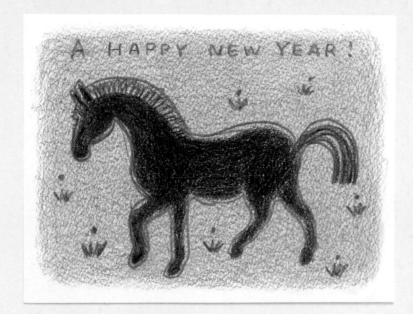

HORSE

The side view of a horse makes for a beautiful silhouette. The horse is dark colored so coloring in the background first and adding the illustration on top of this is a good idea.

SHEEP

Do a stylized drawing of a sheep so as to make the drawing simple. By positioning their faces in different places and making them look in different directions, you can create all types of sheep.

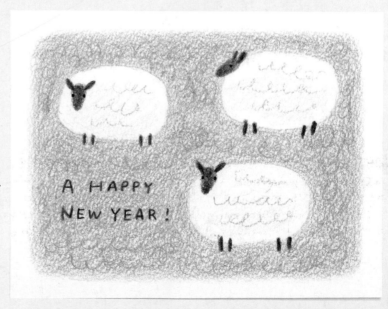

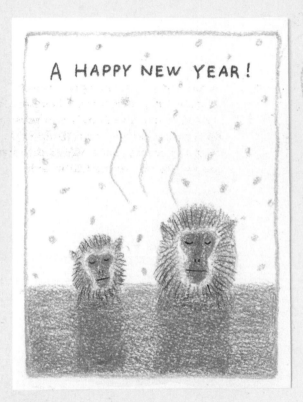

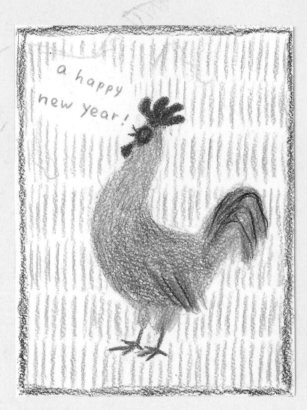

MONKEY

Here is a mother and child monkey enjoying a hot-spring spa. Note that the shape of their faces is like that of green peppers. Color in their faces pink. By changing the shading you can make it look like their faces are being reflected on the water.

ROOSTER

Here is a rooster, energetically crowing with a puffy chest. Using gradation and different levels of shading, you can create a rooster with colorful feathers and a vibrant tail.

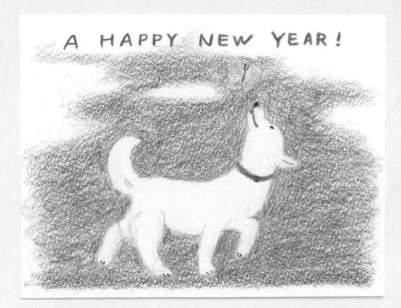

DOG

Here is a white Japanese dog taking a walk. The yellow butterfly in the blue sky makes this illustration come alive. By making the lettering, the dog collar, and the ground the same red color, it keeps things simple. Add a little yellow to its face to give your illustration depth.

WILD BOAR

Don't draw each baby separately but rather draw them as a group of six. If you draw all their eyes and then all their tails and so on, it will be much easier.

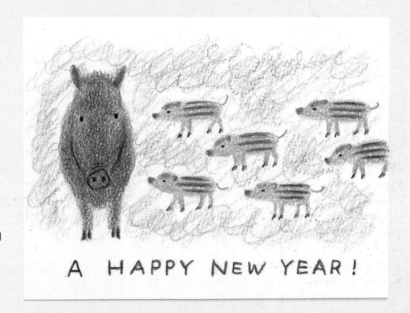

EXPERIMENTING WITH COLORS

If you learn just a little more about colors you will be able to use those colors you don't usually use. When you can't find the color you want, try coloring more boldly or more lightly. Or you could try mixing different colors. Try experimenting.

HERE ARE THE MAIN COLORS

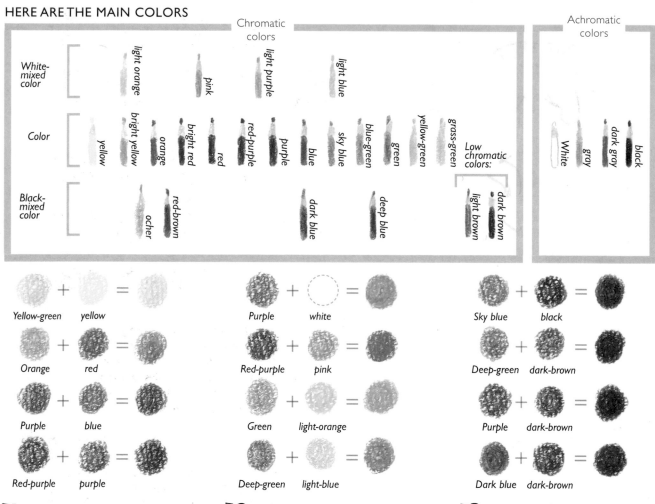

Experiment 1. COLOR ADDITION
By mixing colors that are similar, you can make colors of the same grouping.

Experiment 2. MAKING SUBTLE COLORS
You can make whitish and opaque colors not only by mixing white with a color, but also by mixing it with a "white-mixed color." The way to do this is to first color a dark color lightly. Next, overlay this by coloring a light color boldly.

Experiment 3. MAKING A DARK COLOR
You can make a deep and dark color not only by mixing black with a color, but also by mixing it with a "black-mixed color" like dark brown.

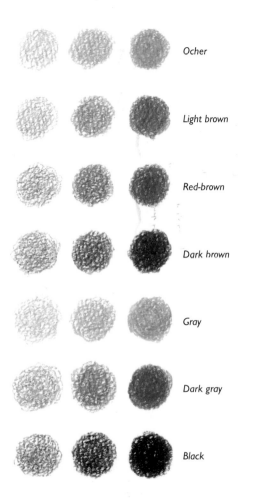

Ocher

Light brown

Red-brown

Dark brown

Gray

Dark gray

Black

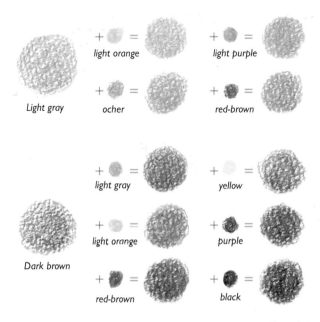

Light gray

+ = light orange

+ = ocher

+ = light purple

+ = red-brown

Dark brown

+ = light gray

+ = light orange

+ = yellow

+ = purple

+ = red-brown

+ = black

5. FINDING DIFFERENT COLORS

Experiment

Often the color of an animal will be very plain, but on close inspection you will be able to see many different colors. Don't just use one color to illustrate your animal, but instead observe the animal carefully and find different colors which are mixed in.

For this book I used Holbein Artists' Colored Pencil — twenty-four colors plus three pencils I bought separately. For the names of the colors I have used names which are commonly used, not the name used by the manufacturer.

Experiment

4. MAKING SUBTLE AND DARK COLORS BY USING DIFFERENT "TOUCHES."

Try experimenting using different "touches" with a color you often use to draw animals. Even with just one color, you can make various different color qualities just by changing your coloring "touch."

ALL ABOUT ANIMALS' HAIR

There are all kinds of animal hairs. Hair length and hair quality is different from one animal to another. Some animals have more than one hair quality depending on the part of the body. If you have a good understanding of the hair quality of the animal you are trying to illustrate you will no doubt be successful in depicting the special characteristics of that animal.

 Longer hair

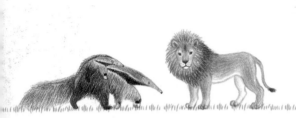 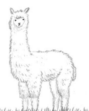

LONG HAIR THICK HAIR

Each hair is long. To draw this hair, sharpen your pencil and draw each line with a "swoosh, swoosh" movement.

BULKY HAIR

This hair can be described as crinkled hair amassed together. To illustrate this hair, hold your pencil horizontally to the paper and make little circular motions. For white hair, draw lines at the edges.

FLUFFY HAIR

This hair is a dense growth of vertical standing hairs. To illustrate this hair, hold your pencil so that it is vertical to the paper, draw multitudes of lines originating from the animals skin and move outward.

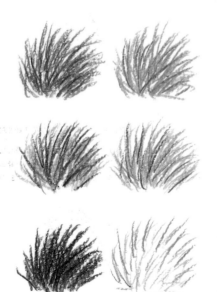 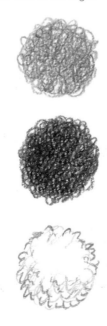 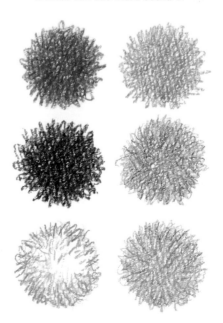

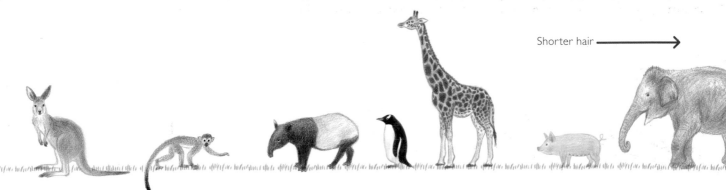

NORMAL HAIR

Hair that is neither long nor short

To draw short hair, hold your pencil horizontally to the paper and color lightly. In this way, each hair will not stand out. For the edges however, draw short lines.

SHINY HAIR

Hair that is short and looks shiny

To illustrate this hair, color in densely so that none of the paper's white remains. The edges of this hair should be made very clear.

SKIN

Thin hair and areas where the flesh can be seen

Using pink and light orange, color in densely.

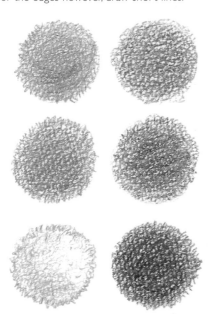

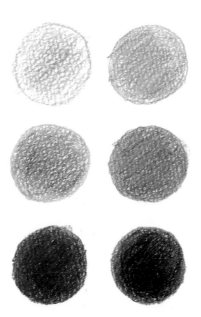

Places where the flesh is exposed

Color in roughly so that your pencil lines remain and then overlay this with a whitish color. Color in densely.

109

ABOUT THE AUTHOR

Ai Akikusa
A picture book, illustrator and 3-D molding artist.
Graduated from the Department of Graphic Design, Tama Art University.
After working at the Nakamori Design Office she is now working as a freelance artist.

Some of her publications to date are as follows:
Easy-to-use Coloring Pencils, Cute Animals with Coloring Pencils (Fujin no tomo sha)
Let's Go To the Zoo, Buk's Baby, Me and My Little Popofu (Kyouikugageki)
The Hairy One (Media Factory)
Asahiyama Zoo (Kadokawa Tsubasa Bunko)
Parudemar the Bear (Bunken Shuppan)
Little Puddle (Suzuki Shuppan)